The
Stammheim
Missal

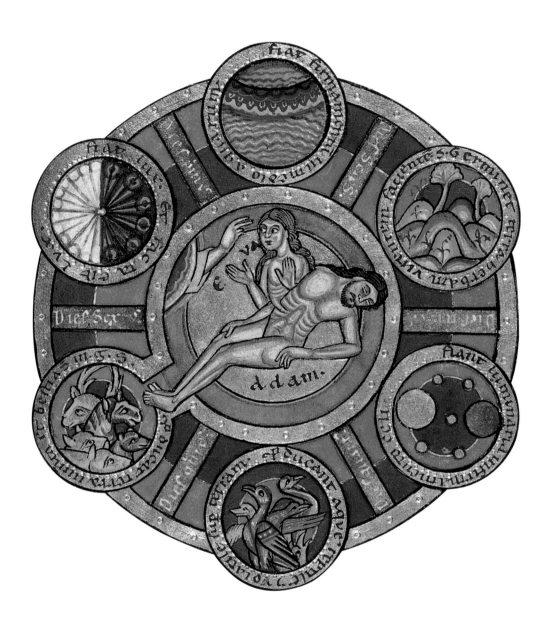

THE STAMMHEIM MISSAL

Hildesheim, probably 1170s

The Wisdom of Creation [detail]
(fol. 10v)

The Stammheim Missal

Elizabeth C. Teviotdale

GETTY MUSEUM STUDIES ON ART

Los Angeles

Christopher Hudson, *Publisher*
Mark Greenberg, *Managing Editor*

Mollie Holtman, *Editor*
Jeffrey Cohen, *Designer*
Suzanne Petralli Meilleur, *Production Coordinator*
Charles Passela, *Photographer*

1200 Getty Center Drive
Suite 400
Los Angeles, California 90049-1681
www.getty.edu/publications

Library of Congress
Cataloging-in-Publication Data

Teviotdale, Elizabeth Cover
 The Stammheim Missal / Elizabeth C.
 Teviotdale.
 p. cm.—(Getty Museum studies on art)
 Includes bibliographical references
 ISBN 0-89236-615-x
 1. Stammheim missal. 2. Illumination
 of books and manuscripts, German—
 Germany—Lower Saxony. 3. Illumination
 of books and manuscripts, Medieval—
 Germany—Lower Saxony. 4. Michaeliskirche
 (Hildesheim, Germany) 5. Illumination
 of books and manuscripts—California—
 Los Angeles. 6. J. Paul Getty Museum.
 I. J. Paul Getty Museum. II. Title. III. Series.
 ND3375.S7 T48 2001
 745.6'7'0943595807479494—dc21
 00-062765

Cover:
Initial *A* with *David and Companion Musicians*
[detail]. Stammheim Missal, Hildesheim,
probably 1170s. Tempera, gold, and silver
on parchment, 184 leaves, 28.2 × 18.8 cm
(11 1/8 × 7 7/16 in.). Los Angeles, J. Paul Getty
Museum, Ms. 64, fol. 12 (97.MG.21).

Frontispiece:
The Wisdom of Creation [detail]. Stammheim
Missal (fol. 10v).

Page vi:
Saint Bernward of Hildesheim [detail].
Stammheim Missal (fol. 156).

The books of the Bible are cited according to
their designations in the Latin Vulgate.
All translations from the Latin are by the author.

Typography by G & S Typesetters, Inc.
Austin, Texas
Printed in Hong Kong by Imago

CONTENTS

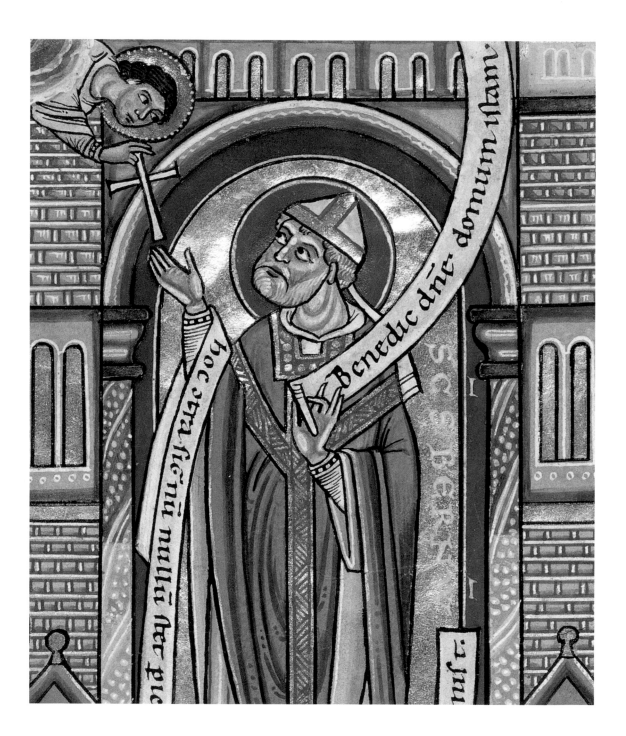

The Stammheim Missal and the Artistic Heritage of the Monastery of Saint Michael at Hildesheim

The Stammheim Missal is one of the supreme monuments of twelfth-century art. A sumptuous religious service book, it was written and decorated entirely by hand in the monastery of Saint Michael at Hildesheim in northern Germany [FIGURE 1]. It remained in the collection of the abbey from its creation, probably in the 1170s, until February 1803, when the monastery was secularized. At that time, the missal came into the possession of the prince-bishop of Hildesheim and Paderborn, Franz Egon, Freiherr von Fürstenberg (1737–1825). In the early twentieth century, the manuscript came to be called the "Stammheim Missal" after the name of the Von Fürstenberg family mansion north of Cologne [FIGURE 2]. The missal remained in the hands of the Von Fürstenberg family until 1997, when the Getty Museum acquired it.

The Stammheim Missal owes its fame to the magnificence of the painted decoration. The miniatures, initials, and decorated text pages, exquisitely executed throughout, are full of variety, yet harmonious in their effect. The sheer beauty of the book's pages is matched by the theological complexity of the illumination, especially as expressed in the full-page miniatures. Indeed, the Stammheim Missal is an extraordinary art object that makes a profound theological statement.

The first chapter of this book will introduce the manuscript, its illumination, and the circumstances surrounding its creation. In the second chapter, the missal's painted decoration will be viewed with an eye to

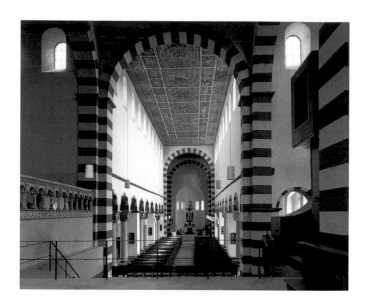

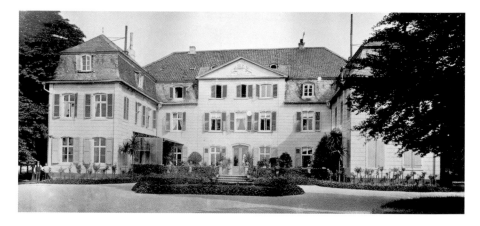

the antecedent tradition of illuminated service books. The medieval history of the representation of Jewish scripture in Christian art will then be sketched, setting the stage for a scrutiny of the missal's full-page miniatures in the next two chapters. The pictorial program as a whole is the subject of the final chapter.

The missal survives in its entirety except for its binding, which has been replaced. The manuscript's illumination is remarkably well

preserved: the colors are as brilliant as the day the paints were applied, the gold still sparkles, and most of the silver remains untarnished. The missal owes its exceptional state of preservation in part to having been regarded even in the Middle Ages more as an object to be treasured than as a book to be read and used. Although we cannot know for certain, it seems that five artisans—four writing the text and one providing all the painted decoration—created the manuscript. Its original binding was probably the work of yet another craftsman. Most probably, all of these artisans were monks of the abbey.

The monastic community of Saint Michael had been in existence for about 150 years at the time the Stammheim Missal was created. Saint Bernward (died 1022), bishop of Hildesheim, founded the monastery just outside Hildesheim's medieval city walls in the early eleventh century. The abbey church was built at Bernward's behest, with the foundation stone laid by him in 1010. The church—consecrated in 1022, the year of Bernward's death—was richly outfitted with art objects that the bishop commissioned especially for it. The most imposing of the church's furnishings was a cast-bronze column over twelve feet tall and covered with scenes from the life of Christ [FIGURE 3]. The column's appearance, with sculpted reliefs arranged in a spiral, directly imitates the look of imperial Roman columns carved to celebrate military victories. The triumph commemorated by Bernward's column is not earthly, however, but spiritual—Christ's triumph over death—and the column was originally topped by a cross.

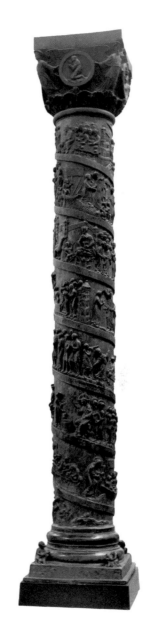

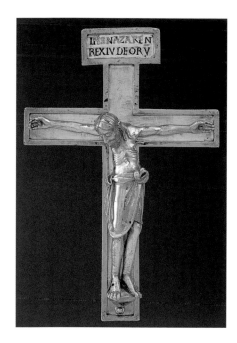

Bishop Bernward also had smaller metalwork objects made for the new monastery's church, including a pair of elaborate candlesticks and a reliquary cross cast in silver and embellished with gold—a remarkable achievement for that time [FIGURE 4]. According to medieval legend, Bernward took a great interest in the arts as a young man, and as bishop he made daily visits to the metal shops and personally inspected the work as it progressed. Bernward is reported to have been trained as a scribe and an illuminator, and he collected and commissioned a number of lavishly illu-

Figure 4
Crucifix, Hildesheim, between 1007 and 1022. Gilt silver, H: 21 cm (8¼ in.). Hildesheim, Dom-Museum (DS 6).

Figure 5
Bernward Presenting His Bible to the Virgin. Bernward Bible, Hildesheim, early eleventh century. Tempera, gold, and silver on parchment, 486 leaves, 45.5 × 34.5 cm (17¹⁵⁄₁₆ × 13⁵⁄₈ in.). Hildesheim, Dom-Museum (DS 61, fol. 1).

Opposite
Figure 6
Ratmann Presenting His Missal to Saints Michael and Bernward. Ratmann Missal, Hildesheim, 1159. Tempera, gold, and silver on parchment, 202 leaves, 34.5 × 24 cm (13⁵⁄₈ × 9⁷⁄₁₆ in.). Hildesheim, Dom-Museum (DS 37, fol. 111v).

Figure 7
Initial *A* with *An Archbishop.* Ratmann Missal, Hildesheim, 1159 (text written circa 1400). Tempera, gold, and silver on parchment, 202 leaves, 34.5 × 24 cm (13⁵⁄₈ × 9⁷⁄₁₆ in.). Hildesheim, Dom-Museum (DS 37, fol. 199v, detail).

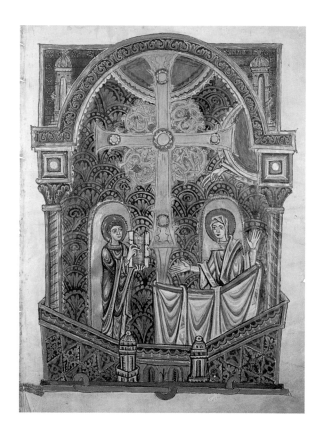

minated manuscripts that were eventually deposited in the church treasury [FIGURE 5]. Inscriptions report to future generations that Bernward bestowed the books on the abbey.

This splendid array of artworks daily reminded the monks of Bernward, whose body was buried in the church's crypt. Indeed, the monks of Saint Michael were devoted to the memory of their founder, and in 1150—about 130 years after Bernward's death—the archbishop of Mainz granted them permission to celebrate Bernward as a saint within the monastery. For the monks, this meant the annual commemoration on January 15 of Bernward's ordination as bishop of Hildesheim in 993 [FIGURE 8] and the communal remembrance of his death each year on November 20.

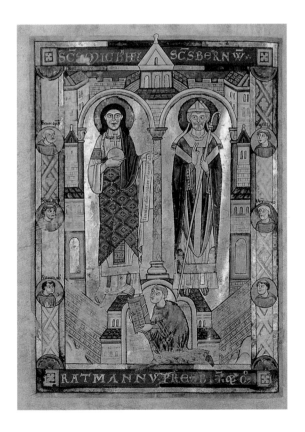

New prayers were composed for the services performed on Bernward's feast days, and this in turn led to the creation of new service books in which the new feast days were properly integrated into the annual liturgy.

One of these new books was the Ratmann Missal, a richly illuminated manuscript completed in 1159 and named for a monk involved in its creation, probably its scribe [FIGURE 6]. It contained the prayers and chants necessary for the celebration of the Christian Mass. An inscription in the manuscript states that it was to be placed on the altar during religious services, and indeed, the Ratmann Missal was used regularly in services at Saint Michael. Its text was apparently updated as the monastery's liturgy developed, and eventually it came to be so filled with additions and corrections that in 1400 the text was entirely scraped away and replaced with an up-to-date version. The scribe who replaced the text carefully preserved most, but not all, of the manuscript's illumination—both full-page miniatures and large, painted initials. The new text was fitted around the 250-year-old illumination, a laborious task [FIGURE 7]. Although the manuscript's textual contents had outlived their usefulness and were replaced, the illumination was preserved as part of the abbey's artistic heritage.

Work on the Stammheim Missal probably began some ten years after Ratmann completed his missal. Despite this time lapse, the two manuscripts are closely related. From the little evidence we have, it seems that the Stammheim Missal's text was virtually identical to the original contents of the earlier manuscript, and some of the illumination is modeled on that in the older book. Nevertheless, the Stammheim Missal stands out from its sister manuscript. Its program of illumination is more ambitious in scope and theological complexity, and the quality of the painting is even higher. With the Ratmann manuscript serving the community's needs during services, the monks most probably always intended to keep the Stammheim Missal in the church treasury, to be used only rarely. There it would preserve the text and music of the monastery's religious rituals and also serve as an expression of fundamental Christian theology in visual form.

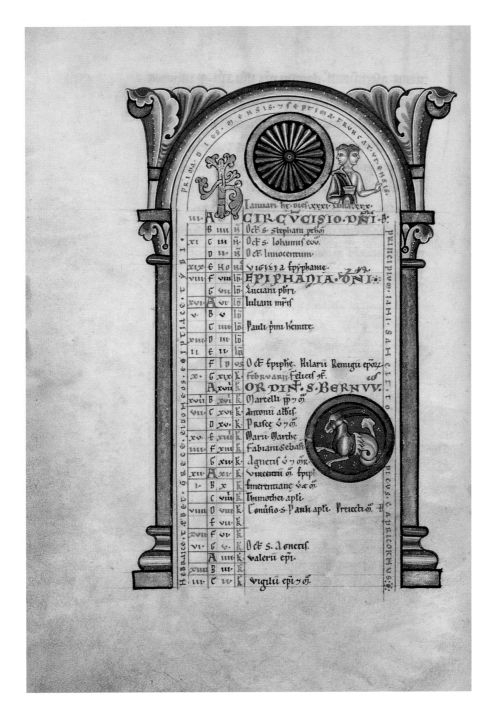

Figure 8
Calendar Page for
January. Stammheim
Missal, Hildesheim,
probably 1170s.
Tempera, gold, silver,
and ink on parchment,
184 leaves, 28.2 ×
18.8 cm (11 1/8 × 7 7/16 in.).
Los Angeles,
J. Paul Getty Museum,
Ms. 64, fol. 3v
(97.MG.21).

Overleaf
Figures 9a–b
Calendar Pages for
September and
October. Stammheim
Missal (fols. 7v–8).

7

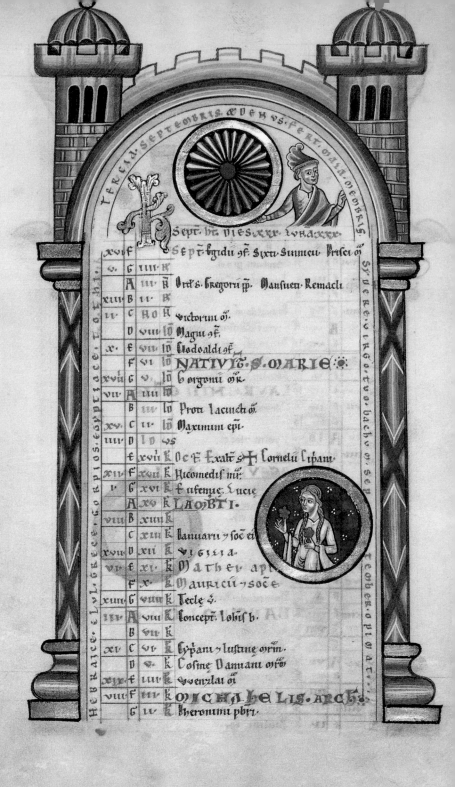

Sept ht dies xxx luna xxx

	G	iiii k	Sept. egidu gf. Sixti Sinneu Prisci ō
v.	A	iii ħ	Ortt s. Gregorii p̄p̄. Mansueti. Remacli
xiii	B	ii ħ	
ii.	C	ħ OH	Victorini ō
	D	viii ɪd	Magni gf
x.	E	vii ɪd	Clodoaldi ō
	F	vi ɪd	NATIVIT S MARIE
xvii	G	v ɪd	Gorgonii ōR
vii	A	iiii ɪd	
	B	iii ɪd	Proti Iacinchi ō
xv	C	ii ɪd	Maximini epi
iiii	D	Id	⁹s
	E	xviii k	Oct E. Exalt ꝫ Cornelii Cypani
xiii	F	xvii k	Nicomedis mr̄
v.	G	xvi k	Eufemie. Lucie
	A	xv k	LAMBTI.
viii	B	xiiii k	
	C	xiii k	Ianuarii ꝫ soč ei
xvi	D	xii k	Vigilia
vi.	E	xi k	Mathei apłi
	F	x k	Mauricii ꝫ soče
xiiii	G	viiii k	Tecle ꝟ
iii.	A	viii k	Concept. Iohis b
	B	vii k	
xi	C	vi k	Cypiani ꝫ Iustine ᵒ̄r̄m
	D	v k	Cosme Damiani ō⁹ō
xix	E	iiii k	Wenzlai ō
viii	F	iii k	MICHAELIS ARCh
	G	ii k	Ieronimi pbr̄i

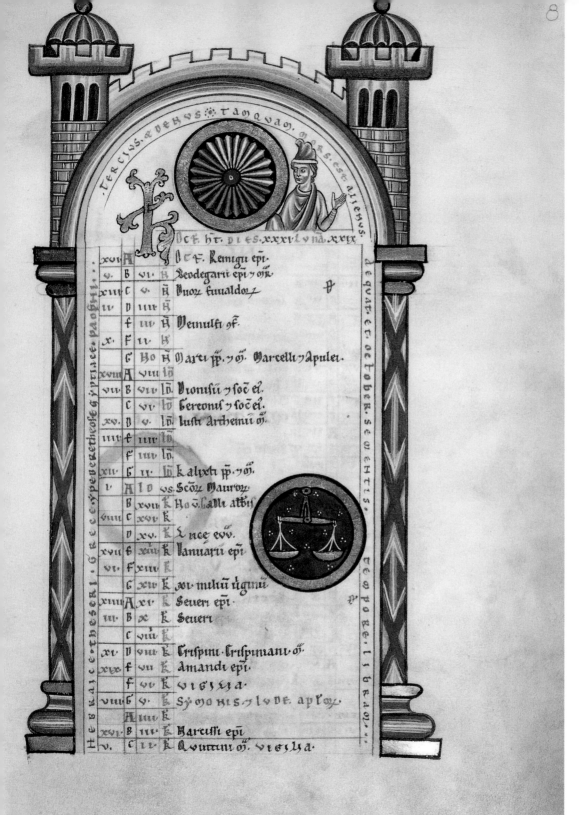

TERCIVS· ABEHOS·:· TANQVAM· MARS·ESTALIENVS·

OCTB· HT· DIES· XXXI· ꝉ nā· XXIX·

xviii	A			OCTB· Remigii epi·
v	B	vi	N	Leodegarii epi· ⁊ os̅r·
xviii	C	v	N	Duox kunualdor
iii	D	iiii	N	
	E	iii	N	Germulfi cōf·
x	F	ii	N	
	G	No	N	Marci pp· ⁊ os̅· Marcelli ⁊ Apulei·
xviii	A	viii	Id	
vii	B	vii	Id	Dionisii ⁊ soc̅ ei·
	C	vi	Id	Sereonis ⁊ soc̅ ei·
xv	D	v	Id	Iusti Arthemii os̅·
iiii	E	iiii	Id	
	F	iii	Id	
xii	G	ii	Id	kalixti pp· ⁊ os̅·
i	A	Id	us	Scōr Mauror
	B	xvii	K	Ho̅ Galli abbis
viiii	C	xvi	K	
	D	xv	K	Luce eu̅s·
xvii	E	xiiii	K	Ianuarii epi·
vi	F	xiii	K	
	G	xii	K	xi miliu uginu̅
xiiii	A	xi	K	Seueri epi·
iii	B	x	K	Seueri
	C	viiii	K	
xi	D	viii	K	Crispini· Crispiniani os̅·
xix	F	vii	K	Amandi epi·
	F	vi	K	VIGILIA
viii	G	v	K	SÝMONIS ⁊ IVDE· aplor·
	A	iiii	K	
xvi	B	iii	K	Narcissi epi·
v	C	ii	K	Quintini os̅· VIGILIA

HEBRAICE· THESCRI· GRECE EXPEREURETHICOS· GÝPTIACE· PAOPHI··

dequat· et· october seqventis·· tempore librao÷·

8

Let us now examine the missal's contents in the order in which they appear with an eye to the type and placement of the painted decoration in each section of the manuscript. The missal contains texts—some with musical notation—prescribed for use in the Christian Mass, prefaced by a calendar. The Mass is the service that has as its focus the sacrament of the Eucharist, in which bread and wine are consecrated and consumed. Some of the prayers and chants of the Mass remain the same throughout the year, but many change with the season or with each day. The Stammheim Missal contains both variable and invariable texts needed to perform the Mass throughout the year, altogether over 350 pages of chants, readings, prayers, instructions, and illumination.

The missal opens with a calendar that indicates for each day whether a particular saint or holy event is to be commemorated. The calendar extends over twelve pages, with each page devoted to one month [FIGURES 8 AND 9A–B]. Each line on the page represents one day of the month, identified according to the ancient Roman system of counting days leading to the Kalends, the Nones, and the Ides of the month, as well as by a system of letters from A through G that indicates the cycle of the days of the week. The names of events or saints to be commemorated are written on the appropriate line, and there is a visual hierarchy among the entries. Most are written in black or red, but those for the most solemn feast days and the saints particularly venerated at the abbey are entered in display capital letters in alternating colors. The entry for the feast of Saint Michael, the monastery's patron saint, for example, is written in red and green capitals on the line for September 29 [FIGURE 9A]. Each page of the calendar also has three inscriptions. Along the left side are given the alternative names of the month in Greek, Hebrew, and "Egyptian." The verse that curves along the top of the page identifies the two unlucky days in that month. The inscription for October reports, for example, that the third and the tenth from the end are inauspicious days [FIGURE 9B]. The verse along the right side of the page is taken from a poem by the fourth-century rhetorician Ausonius and alludes to the zodiacal sign for that month.

The embellishment of each calendar page is architectural, with an arch spanning columns on either side of the text, and each pair of facing pages is given a harmonious decorative treatment [FIGURES 9A–B]. The illumination includes a circular diagram under the arch that shows the number of hours of daylight and darkness in a typical day of that month. In September, for example, twelve hours of day and twelve hours of night are shown, but in January only eight hours of daylight are indicated. Next to each circular diagram is a bust-length figure. These figures are not always identifiable. The figure for January is the two-faced Roman god Janus, who gave his name to the month, but many of the figures are anonymous youths whose meaning is difficult to decipher. Finally, the sign of the zodiac for the month is pictured in a small medallion placed toward the lower right of the page.

The calendar is followed by a series of three full-page miniatures that serve as frontispieces to the text proper of the manuscript. The first two present the theme of the Wisdom of Creation [FIGURES 43A–B], and the third the Annunciation to the Virgin [FIGURE 44]. The Annunciation miniature also introduces the next section of the book, the portion that contains the chants sung by the choir—and soloists of the choir—in the celebration of the Mass. This music section of the missal occupies 124 pages. First come the songs that change with each feast day, arranged in an annual cycle beginning with the First Sunday of Advent, the season of preparation for Christmas. The decoration of this portion of the missal comprises large, painted initials that introduce the fifteen most important feast days.

In three instances, these initials contain what might be termed author portraits. The most spectacular of these is the nearly full-page initial *A* at the beginning of the section of chants [FIGURE 10]. King David and two companion musicians occupy medallions at the top and along the sides of the letterform. The text of the chant is taken from Psalm 24. Since King David was the author of the psalm, it is appropriate that he should appear, crowned and with a lyre, at the top of the initial. The lyre is his attribute as author of the psalms, based on the ancient tradition of poets accompanying themselves on stringed instruments. It also alludes to

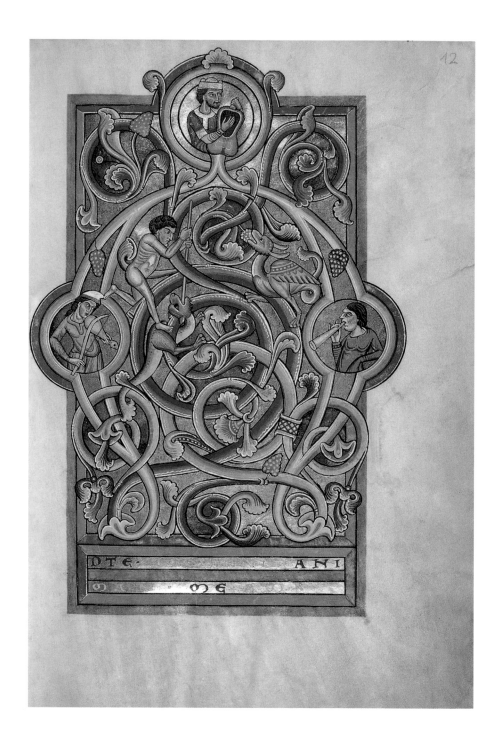

Figure 10
Initial *A* with *David and Companion Musicians*. Stammheim Missal (fol. 12).

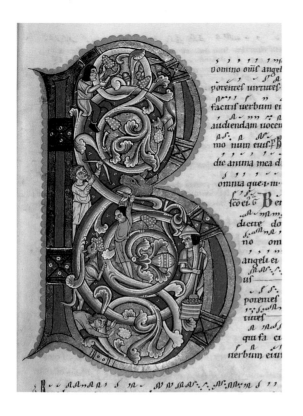

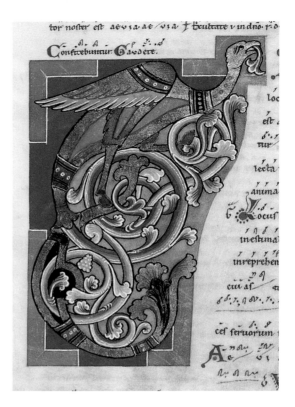

David's important role in Jewish ritual music; he was responsible for the establishment of a variety of musical practices in connection with the translation of the Ark of the Covenant to Jerusalem. The other two musicians in the initial represent his companions in those rituals.

Anonymous figures and animals often inhabit the initials. Although the figures cannot be specifically identified, they often interact with one another. One of the largest and most impressive of these inhabited initials is the *B* that introduces the feast of Saint Michael [FIGURE 11]. While three men are involved in harvesting grapes and crushing them in a vat, two others attack little animals that try to eat the grapes. Some initials are simply composed of geometric, foliate, zoomorphic, or anthropomorphic elements. To say this is not to deny their inventiveness, as can be seen, for example, in the decorated initial *T* [FIGURE 12] formed partly

Figure 11
Inhabited Initial *B*.
Stammheim Missal
(fol. 58, detail).

Figure 12
Decorated Initial *T*.
Stammheim Missal
(fol. 52v, detail).

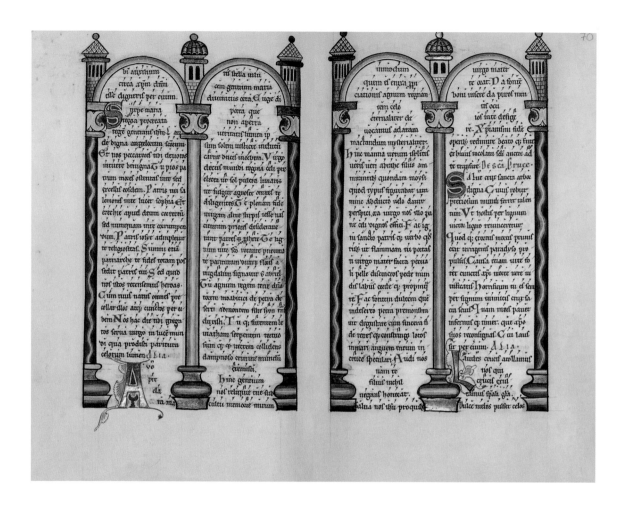

Figures 13a–b
Decorated Text Pages.
Stammheim Missal
(fols. 69v–70).

of a bird-beaked and winged dragon that introduces the chants for the feast of the Dedication of a Church.

After the chants that are specific to individual feasts come the songs whose texts remain the same throughout the year. These are arranged on pages of two columns of text and musical notation under painted arcades. As in the calendar, the decorative treatment of facing pages is harmonized. The chants that follow—called sequences—are arranged in an annual cycle beginning with Christmas. These songs, like

the preceding, are written in two columns to a page within a painted architecture of columns and arches [FIGURES 13A–B]. Altogether there are twenty-nine consecutive pages with painted arcades, which create a rich and dazzling effect as the pages are turned. A short section of readings—without significant painted decoration—separates the end of the section of the missal devoted to the music portions of the Mass from the section containing prayers.

The next section of the missal is the largest. It contains the prayers said by the priest during Mass. First come the prayers that remain constant—albeit some with seasonal variations—throughout the year. These are the prayers recited by the priest just before and while bread and wine are prepared for the mystical meal called the Eucharist. The introductory prayer, called the *Vere dignum* after its opening words, appears in ten variations on the opening five pages of this portion of the missal. The repeated monogram *VD*, which represents not merely the opening words but the opening line (*Vere dignum et justus est*) of the prayer in all its versions, is the main decorative accent [FIGURE 14]. The text of the last two of these five pages is written in colored inks and precious metals on colored backgrounds [FIGURES 19A–B]. A pair of full-page miniatures—*Christ in Majesty* and *The Crucifixion*—follows [FIGURES 46A–B]. These images play a dual role; they both continue the sequence of frontispiece miniatures and introduce the next portion of the text, the Eucharistic prayers.

The prayers that change with each feast day take up the next 190 pages. The decoration of this portion of the manuscript is especially rich. There are twenty-eight large painted initials, and each of seven feasts is marked by a full-page miniature as well as a painted initial letter. There are miniatures for Christmas, Easter, the Ascension, Pentecost, the Assumption of the Virgin (August 15), the feast of Saint Michael (September 29), and the feast of Saint Bernward (November 20) [FIGURES 47–53]. The first five are solemn feasts of the universal Church, while Michael and Bernward were saints of particular significance to the monks of Saint Michael. The

Figure 14
VD Monogram.
Stammheim Missal
(fol. 83).

miniatures for the feasts of the universal Church include a great number of figures and inscriptions organized into comprehensive geometric schemes. The miniatures for the saints' days are less complex but every bit as powerful in their imagery.

Some of the painted initials in this section of the manuscript contain narrative scenes that are inspired by their liturgical context. The letter *D* that opens the feast of Saints Peter and Paul, for example, shows the Fall of Simon Magus, an episode from a legendary account of Peter and Paul's ministry in Rome [FIGURE 15]. There are also many initials inhabited by anonymous figures and animals, like the *D* for the feast of Saint Michael, with its naked men, strange reptile, and mischievous bird [FIGURE 16].

The sumptuousness of the Stammheim Missal's decoration was undoubtedly inspired by the important artistic heritage of the abbey of

Figure 15
Initial *D* with *The Fall of Simon Magus.* Stammheim Missal (fol. 138v, detail).

Figure 16
Inhabited Initial *D.* Stammheim Missal (fol. 152v, detail).

Saint Michael. The monks were well acquainted with their founder's interest in art, and they daily encountered magnificent art objects commissioned by him. Those who were involved in the making of the Stammheim Missal must also have known and studied the illuminated manuscripts Bernward gave the monastery. Having been granted the privilege of celebrating Bernward as a saint within the monastery's walls, the monks needed new liturgical books, but only the most beautiful could do justice to their founder, who had commissioned so many splendid works of art. Not one but two illuminated missals were created over the course of the following generation, one—the Ratmann Missal—to serve the monks' needs in services, the other—the Stammheim Missal—to be treasured. The Stammheim Missal was more than a repository of the abbey's liturgy with the new Bernward feasts integrated into the annual cycle—it was also a monument to Bernward's keen interest in art.

Observations on
Early Medieval Mass Books
and Their Illumination

The Stammheim Missal's painted decoration is extraordinarily rich and inventive, but its overall plan owes a debt to the early medieval tradition of illuminated religious service books. It will be useful, therefore, to explore this tradition, focusing our attention on the books used in the celebration of the Mass. The Mass involves ritual action accompanied by prayers, readings, and chants. During the course of the early centuries of the Christian Church, those actions and words came to be fixed: improvised prayer was replaced by prescribed texts, whose authority was guaranteed by their appearance in written form. The celebrating priest knew what to say at Mass on a given feast day because it was fixed on parchment in books called sacramentaries. Similarly, the singers—both soloists and the choir—knew the songs to be sung because they were written down in manuscripts called graduals. At first only the texts of the chants were copied out, but eventually musical notation was also included. Passages from scripture were sometimes read from Bibles and Gospel books, but the particular passages to be read at Mass were also excerpted and arranged in liturgical order in books called lectionaries.

In short, there was in the early Middle Ages a transition from improvised communal ceremony to prescribed ritual and from oral to written tradition. Even after the medieval liturgy was preserved in writing, however, the texts of service books were not identical throughout

Europe. There are fundamental reasons for this. The most basic is that the books of the Middle Ages were copied by hand, which meant that each was unique. A particular prayer, chant, or reading might or might not be included in a given book, and the order of presentation differed from manuscript to manuscript. Furthermore, omissions, additions, errors, and corrections were all part of the copying process. Another reason that service books were not uniform is that regional and local variations in liturgical practice affected both the forms of the prayers and the feast days included. The liturgy also changed over time, with new feasts—such as the feasts for Saint Bernward at Hildesheim—being added. Finally, the distinction among the types of book just described—the sacramentary for the celebrating priest, the gradual for the singers, and lectionaries for the readers of the biblical lections—was not always strictly maintained. Volumes that combine the functions of more than one of these books are called missals, as is evident from the name of the Stammheim Missal itself. As we shall see, just as the Stammheim Missal brings together the contents of the gradual and the sacramentary, so too is its decoration rooted in the traditions for illuminating those books.

Liturgical books came to be illuminated in the eighth century, when sacramentaries began to have painted embellishment at the beginnings of major sections of the text. Because sacramentaries served as part of the adornment of the altar during Mass, it was natural that they would be illuminated, especially when they were made for presentation to high-ranking political or church officials. The decorated pages of the earliest illuminated sacramentaries often feature representations of the cross—a central motif of Christian art. In a sacramentary from Chelles in northern France, for example, one page includes a cross flanked by eagles [FIGURE 17]. Hanging from the arms of the cross are the shapes of the Greek letters alpha and omega formed of fish. This is a reference to Christ's proclamation to Saint John the Divine, as reported in the Apocalypse: "I am alpha and omega, the beginning and the end" (Apocalypse 1:8). The cross therefore

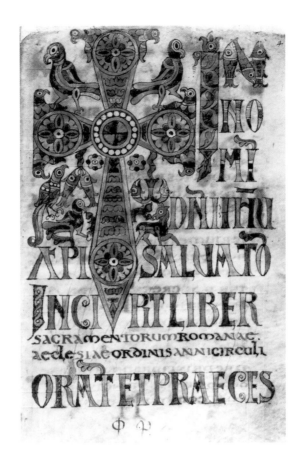

appears here as the sign of the eternal Christ. The text that follows is written in multicolored capital letters that include fish and foliate forms.

Decorated text pages continued to be a feature of illuminated sacramentaries throughout the early Middle Ages. The pages at the beginning of the section of the manuscript with the invariable prayers often received the most elaborate treatment. Monograms formed of the letters *V* and *D*—the initials of the opening words of the prayer *Vere dignum*—frequently provided major decorative accents. The words on these pages are often of gold or, more rarely, silver set against a dark painted background [FIGURE 18A]. The Stammheim Missal's *Vere dignum* pages follow

Figure 17
Decorated Text Page. Sacramentary, Chelles, shortly before 750. Tempera on parchment, 245 leaves, 26.1 × 17.4 cm (10¼ × 6⅞ in.). Vatican City, Biblioteca Apostolica (Ms. Reg. Lat. 316, fol. 4). © Biblioteca Apostolica Vaticana.

21

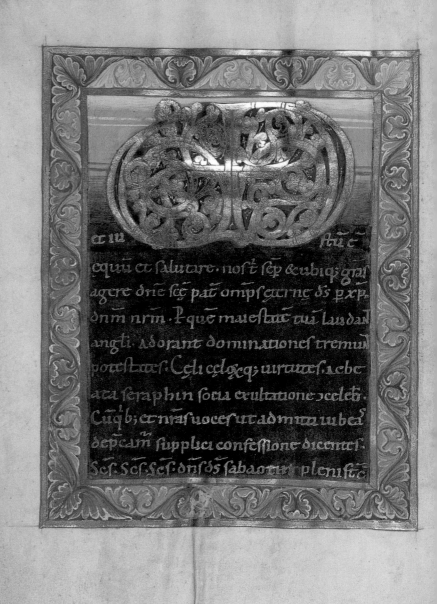

et iu̅ stu̅ c̅

eq̅uu̅ et salutare. nost sep̅ & ubiq̅; g̅ra̅s
agere d̅r̅e s̅c̅e pat omps̅ eterne d̅s p̅ x̅p̅m̅
d̅n̅m n̅r̅m. P̅ que maiestu̅ tu̅ laudan̅t
angti. adorant dominationes tremu̅t
potestates: Celi celo̅x̅q̅; uirtutes. ac be
ata seraphin socia exultatione celeb.
Cuq̅b; et n̅r̅as uoces ut admitti iubeat
dep̅ca̅m supplici confessione dicentes.
S̅c̅s. S̅c̅s. S̅c̅s. d̅n̅s d̅s sabaoth. pleni st̅ c̅

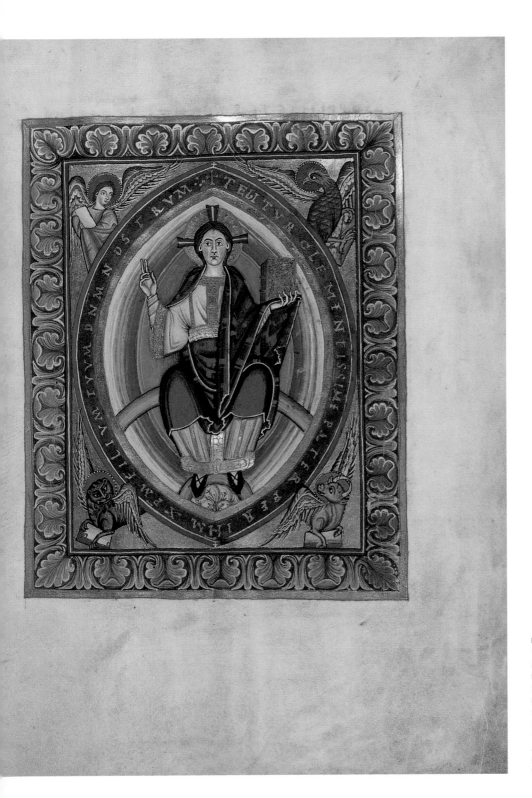

Figures 18a–b

VD Monogram; *Christ in Majesty.* Sacramentary, Mainz or Fulda, circa 1025–50. Tempera and gold on parchment, 179 leaves, 26.6 × 19.1 cm (10½ × 7⁹⁄₁₆ in.) Los Angeles, J. Paul Getty Museum (Ms. Ludwig V 2, fols. 21v–22).

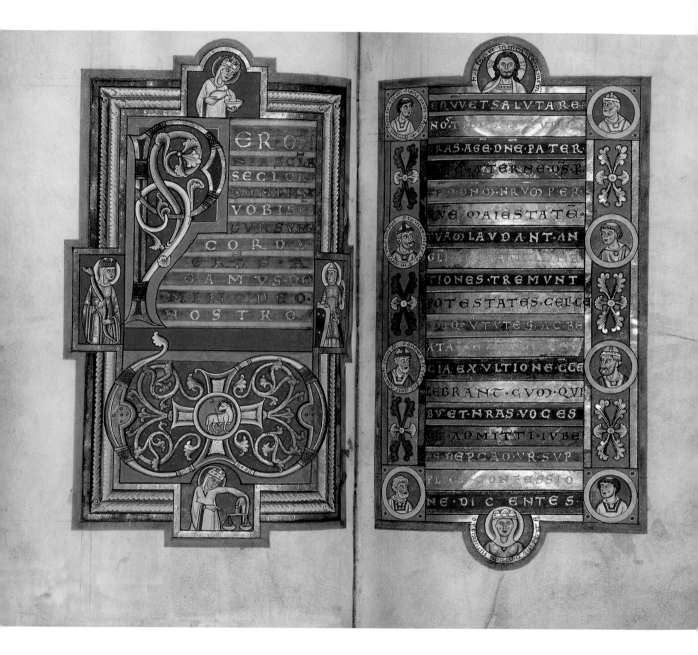

Figures 19a – b
Decorated Text Pages.
Stammheim Missal
(fols. 84v – 85).

this long-standing custom, with the last two pages featuring writing in precious metals on colored grounds [FIGURES 19A–B]. These pages are modeled closely on the corresponding pages in the Ratmann Missal [FIGURES 20A–B].

In both missals, personifications of the four cardinal virtues appear in compartments in the frame of the left-hand page. In the Stammheim Missal, Temperance, shown measuring a liquid, is at the top. At the right is Fortitude in armor, at the bottom Justice with a scale, and at the left Prudence holding a serpent. Curiously, their arrangement on the page is different in the Ratmann manuscript, where they are labeled. The cardi-

Figures 20a–b
Decorated Text Pages.
Ratmann Missal,
Hildesheim, 1159.
Tempera, gold, and silver
on parchment, 202
leaves, 34.5 × 24 cm
(13⅝ × 9⁷⁄₁₆ in.).
Hildesheim,
Dom-Museum (DS 37,
fols. 118v–119).

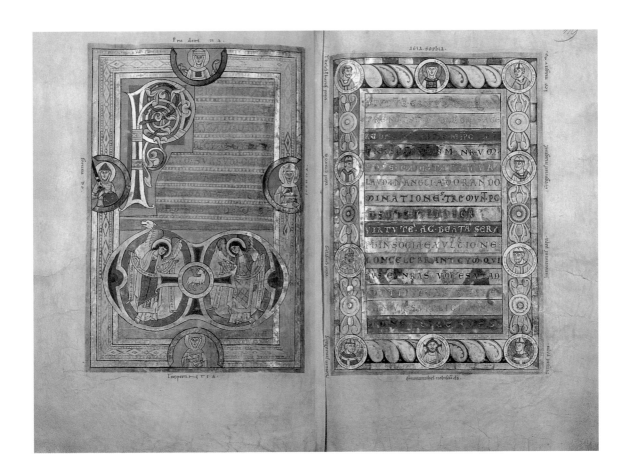

nal virtues have a place here because early Christian commentators iden-
tified them as the benefits to be derived from the Eucharist by the Chris-
tian faithful.

Christ and a personification of Wisdom are contained within
medallions at the top and bottom of the right-hand pages. The inscription
around Christ in both manuscripts records his words as he distributed
bread to the apostles at the Last Supper: "Do this in commemoration of me"
(Luke 22:19). The biblical inscriptions surrounding Wisdom differ between
the two manuscripts, but both are understood in a Christian context to
refer to the Eucharist. These figures are labeled in the Ratmann Missal, but
they appear in the opposite arrangement and without identifying inscrip-
tions in the Stammheim Missal. Popes and priests are depicted in a series
of medallions along the sides of the pages. Once again, they are named in the
Ratmann manuscript but appear without labels in the Stammheim Missal.
They are, for the most part, early popes credited with having introduced
certain texts into the liturgy of the Mass.

Calendars were a fairly common feature of sacramentaries and
missals—and to a lesser extent graduals—by the twelfth century, but they
did not customarily receive elaborate decorative treatment. The Ratmann
Missal's calendar, for example, is entirely without painted decoration.
The signs of the zodiac and personifications of the planets are sometimes
included in early medieval calendars, as in a tenth-century illuminated
sacramentary from Fulda [FIGURE 21]. The calendar in this manuscript,
like the calendar in the Stammheim Missal [FIGURES 8 AND 9A–B], is
remarkable for the inclusion of inscriptions recording the Hebrew and
Greek names of the months and the verses from Ausonius. The unlucky
days of each month are also identified in the Fulda manuscript, although
with different verses from those in the Stammheim Missal. An inscription
on each page in the Fulda calendar gives the number of hours of daylight
and darkness in a typical day of each month. In the Stammheim Missal the
same information is given, but in diagrammatic form. The Fulda sacramen-
tary, therefore, offers precedents for some of the more intriguing aspects

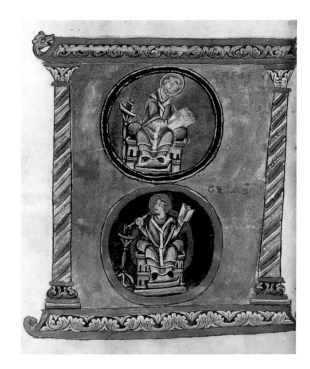

Figure 21
Calendar Page for
September.
Sacramentary, Fulda,
circa 980. Tempera,
gold, and ink on
parchment, 257 leaves,
34 × 27 cm (13³⁄₈ ×
10⁵⁄₈ in.). Göttingen,
Niedersächsische
Staats- und
Universitätsbibliothek
(Ms. theol. 231 Cim.,
fol. 255).

Figure 22
*Popes Gregory and
Gelasius.* Sacramentary,
Fulda, between 997
and 1011. Tempera and
gold on parchment,
225 leaves, 22.4 ×
16.5 cm (8⁷⁄₈ × 6¹⁄₂ in.).
Bamberg,
Staatsbibliothek
(Ms. Lit. 1, fol. 12v).
Photo: Staatsbibliothek
Bamberg.

of the missal's calendar, but the deluxe decorative treatment of the calendar pages in the Stammheim Missal is unusual.

Frontispiece miniatures are an important component of the figural decoration of illuminated sacramentaries of the early Middle Ages. The favored subject of sacramentary frontispieces was Saint Gregory the Great, the sixth-century pope who was credited in the Middle Ages with having codified the liturgy of the Mass. He sometimes appears together with Gelasius I, a fifth-century pope who composed a number of Mass prayers [FIGURE 22]. Another possible subject for the frontispiece is the person, especially if high-ranking, for whom the manuscript was made. Other subjects, including Old and New Testament themes, appear more rarely. The presence of frontispieces per se in the Stammheim Missal, therefore, follows an established pattern, but the missal's suite of thematically related frontispieces [FIGURES 43A–B AND 44] marks a significant departure from tradition.

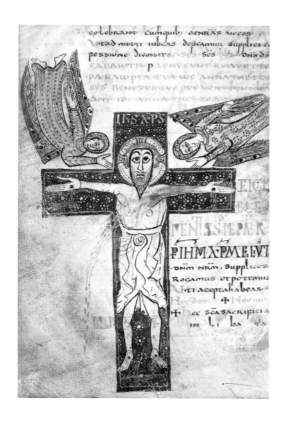

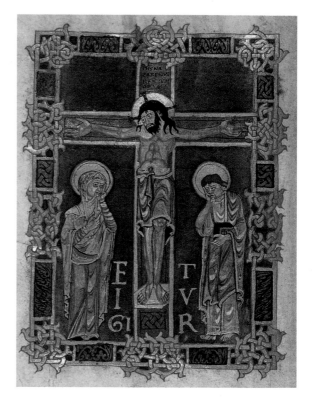

An initial in the Gellone Sacramentary, an eighth-century manu-
script from northern France, inaugurates the most prevalent and long-
lasting pictorial tradition in the illumination of sacramentaries and
missals [FIGURE 23]. At the beginning of the section of the book containing
the Eucharistic prayers, the illuminator has transformed the initial letter
T of the first prayer—called the *Te igitur* after its opening words—into
the cross of the Crucifixion. Christ is shown on the cross, blood streaming
from his wounds, with a pair of angels hovering above. Since the sacrament
of the Eucharist was understood to be a commemoration of Christ's sacrifice
on the cross, this subject is particularly appropriate here. Furthermore,
the emphasis on the body and blood of Christ called attention to their
mystical presence in the consecrated bread and wine of the sacrament.

The image of the Crucifixion in the Gellone Sacramentary appears in the midst of a page of text, but in later centuries illuminators placed more emphasis on this scene. In a sacramentary fragment of the early eleventh century, for example, the opening letters of the prayer *Te igitur* are included within a full-page framed miniature of the Crucifixion [FIGURE 24]. Eventually the image of the Crucifixion appears as an independent miniature, with the prayer beginning on the next page, as in the Stammheim Missal, so that the Crucifixion miniature acts as a frontispiece to that section of the manuscript.

The presence of an image of the Crucifixion at the beginning of the Eucharistic prayers—whether incorporating the initial *T* or an independent miniature—is one of the most stable and enduring traditions of all medieval manuscript illumination. Nevertheless, other subjects were sometimes chosen, the most prevalent being Christ in Majesty. This theme was inspired by the acclamation *Per omnia saecula*, said by the priest before the preparation of the Eucharistic elements, which alludes to the Lord's eternal reign. In an eleventh-century sacramentary made at the behest of Archbishop Bardo of Mainz, for example, Christ is shown seated on a rainbow within an almond-shaped aureole with his right hand raised in blessing [FIGURE 18 B]. Four winged creatures, symbolizing the authors of the four Gospels, turn their heads to see Christ from their vantage points in the four corners of the composition. The beginning of the *Te igitur* is inscribed around the aureole. This image is based in part on Saint John the Divine's vision of the events at the end of time recorded in the Apocalypse, and it evokes the belief that Christ will return at the end of time to judge all humanity. The two images most frequently linked to the Eucharistic prayers—Christ in Majesty and the Crucifixion—were sometimes paired, as in an eleventh-century sacramentary from the royal abbey of Saint Denis near Paris [FIGURES 25A–B]. The illuminator of the Stammheim Missal adopted this pairing, although the visual interpretation of the themes is unique [FIGURES 46A–B].

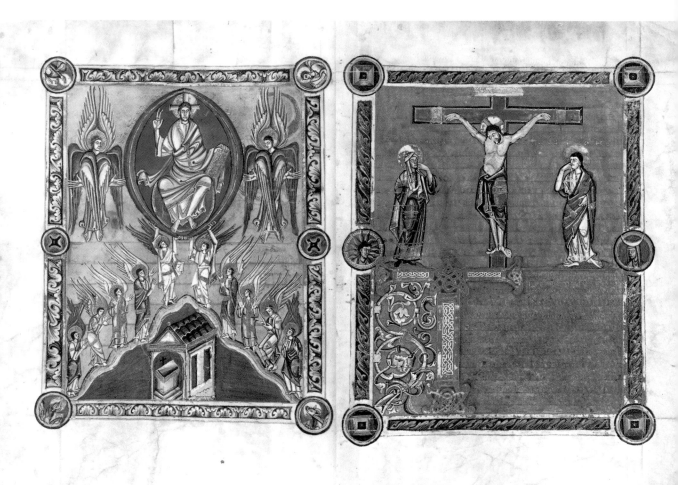

Figures 25a–b
Christ in Majesty;
The Crucifixion.
Sacramentary, Saint-
Denis, mid-eleventh
century. Tempera and
gold on parchment,
165 leaves, 31 × 23 cm
(12 3/16 × 9 1/16 in.). Paris,
Bibliothèque nationale
de France (Ms. lat.
9436, fols. 15v –16).

Some of the most richly illuminated early medieval sacramentaries include narrative scenes that introduce the prayers to be recited on important feast days. The subjects of the scenes are inspired by the events commemorated. A mid-ninth-century sacramentary made for Archbishop Drogo of Metz is an important early example. In that manuscript, diminutive figural scenes occupy the opening initials of the prayers for the most solemn feasts. For example, the infant Jesus, the Virgin, a midwife, and

Joseph are tucked into the top of the *C* composed of golden foliage that opens the prayers for Christmas [FIGURE 26]. The Christ Child is being bathed at the bottom of the letter, and a group of shepherds learns of the birth of the Child within twining vines in the middle.

By the eleventh century, the appropriate narrative scene for a feast day was more commonly presented in a framed miniature, either full-page or smaller, placed at the beginning of the prayers for the feast in question. For example, a miniature depicting Christ lifting the soul of the Virgin Mary to heaven at her death introduces the feast of the Assumption of the Virgin in an eleventh-century sacramentary from Reichenau [FIGURE 27]. A decorated initial customarily follows such miniatures. In the Fulda sacramentary whose calendar we have already examined, the miniatures and the initials are combined with a colored background and display

Figure 26
Initial *C* with *The Nativity and the Annunciation to the Shepherds.* Drogo Sacramentary, Metz, circa 844–55. Tempera and gold on parchment, 130 leaves, 26.4 × 21.4 cm (10 3/8 × 8 7/16 in.). Paris, Bibliothèque nationale de France (Ms. lat. 9428, fol. 24v).

31

Figure 27

The Assumption of the Virgin. Sacramentary, Reichenau, early eleventh century. Tempera and gold on parchment, 219 leaves, 23 × 18 cm (9 1/16 × 7 1/8 in.). Paris, Bibliothèque nationale de France (Ms. lat. 18005, fol. 118v).

Figure 28

Pentecost. Sacramentary, Fulda, circa 980. Tempera and gold on parchment, 257 leaves, 34 × 27 cm (13 3/8 × 10 5/8 in.). Göttingen, Niedersächsische Staats- und Universitätsbibliothek (Ms. theol. 231 Cim., fol. 82).

script to introduce the major feasts [FIGURE 28]. Sacramentaries with miniature cycles only rarely also feature initials with figural scenes. More commonly, a simple decorated initial introduces each feast. The illumination of the last section of the Stammheim Missal generally follows this tradition. The missal is remarkable, however, in the complexity of its miniatures and in the frequent inclusion of figures or narrative scenes within the initials, even when introducing a feast also marked by a miniature.

Graduals—manuscripts containing the chants of the Mass—were less likely to be sumptuously illuminated than sacramentaries in the early Middle Ages. This is principally because graduals, consulted only by the leader of the choir, had no place in the adornment of the church during the service. The earliest graduals contain only the texts of the chants, indicating that the melodies were transmitted by oral tradition. Even when the melodies were written down, the notation—at least in the German-

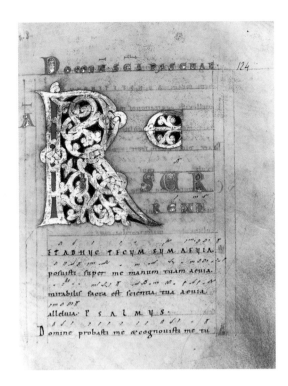

speaking regions—recorded only the contours and not the exact pitches of the music. The choirmaster would consult a gradual in advance of the service in order to refresh his memory. He then taught the chants for a given feast to the choir, who sang them from memory during the liturgy. The oral tradition, therefore, played a significant role in the music of the Mass throughout the early Middle Ages, which in turn had an impact on the embellishment of the manuscripts.

Few surviving early medieval graduals have a cycle of narrative scenes, either within initials or as miniatures. Frontispieces are likewise rare. When graduals received painted decoration at all, it was customarily in the form of nonfigural decorated initials in the section of the manuscript containing the chants that vary from feast day to feast day [FIGURE 29]. An eleventh-century gradual made for Saint-Denis is unusual in including narrative scenes and identifiable figures within some of its ini-

Figure 29
Decorated Initial *R*.
Gradual, Minden (?),
between 1022 and
1036. Tempera and
gold on parchment, 234
leaves, 19.5 × 13 cm
(7 11/16 × 5⅛ in.). Berlin,
Staatsbibliothek
Preußischer Kulturbesitz
(Ms. theo. lat. 4° 15,
fol. 124). Photo: Foto
Marburg/Art Resource,
New York.

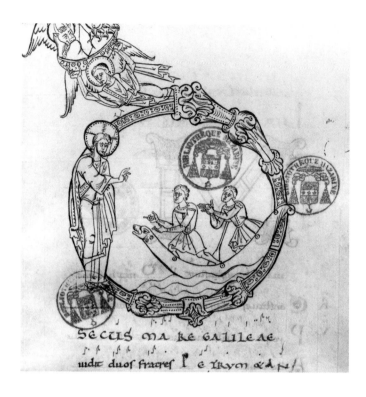

tials. The texts of the chants played a formative role in establishing the subjects for the initials. For example, the initial *D* that begins the feast of Saint Andrew contains the image of Christ calling the fishermen Andrew and Peter to follow him [FIGURE 30]. The scene illustrates the text of the first chant, which describes Christ calling the apostles from the shore. The initial does not show the event actually commemorated on Saint Andrew's feast day—his death as a martyr. Whereas in sacramentary illustration the initials and miniatures most often depict the celebrated event, in chant books the rare figural scenes often take their inspiration from the immediately following song texts. The Stammheim Missal's author portraits in the section of chants follow this principle.

The songs whose texts remain the same throughout the year, and also the sequences, only very rarely received a decorative accent in early graduals. The painted arcades of the Stammheim Missal's invariable

chants and sequences are without precedent among surviving manuscript graduals. Indeed, the two-column format itself marks a departure from the norm.

Lectionaries, like sacramentaries, were physically present during the liturgy of the Mass. The Gospel lectionary was carried into the church during the procession at the beginning of Mass and was then carried in another procession just before the reading. It was therefore natural that lectionaries came to be illuminated. The tradition of illuminating Gospel lectionaries has little bearing on the Stammheim Missal, however, as the missal's brief section of readings is without significant embellishment.

To summarize, the illumination of the Stammheim Missal is at once rooted in the early medieval tradition of deluxe service books for the Mass and a remarkable departure from it. The formats are often consistent with established practice: frontispieces; painted initials for the variable chants; decorated text pages featuring the *VD* monogram for the *Vere dignum*; *Christ in Majesty* paired with *The Crucifixion* for the Eucharistic prayers; and miniatures combined with painted initials for the variable prayers. The architectural treatment of the calendar pages as well as the arcades over the chants with unchanging texts and the sequences, however, are without precedent. More importantly, the complexity of the miniatures marks a significant departure from tradition and distinguishes the Stammhcim Missal from all its predecessors.

Jewish Scripture in Christian Art of the Middle Ages

The sacred writings of Judaism—the Old Testament of the Christian Bible—have held an important place in Christian theology since the earliest times. According to the Gospel accounts of his life, Jesus addressed his teachings almost exclusively to his fellow Jews, citing the Hebrew Bible frequently. He interpreted Jewish law and quoted often from the psalms and the prophets. Indeed, the scripture inherited from Judaism was the only scripture of Christianity until the second half of the second century. At that time, the letters of Saint Paul and the accounts of Christ's life attributed to Saints Matthew, Mark, Luke, and John were brought together to form the New Testament of the Christian Bible.

We learn from the Gospels that Jesus assumed the authority of Jewish scripture and that he announced his coming as a fulfillment of Jewish prophecy. Indeed, the modern Western idea of prophecy is a Christian one. The common twentieth-century usage of the English word "prophet" as "one who foretells the future" is based on its Greek root, meaning "one who speaks before." The Hebrew term *nābî* means "one who is called," and the Hebrew prophets were understood in their own time to have been called to deliver messages from God to humans, especially to kings. Through most of the biblical period of Israel's history, the prophets made "predictions" only of events in the immediate future, generally the unhappy consequences of continued bad behavior on the part of the Israelites. The exception is to be found only very late, after

the fall of both Israelite kingdoms, in the prophecies of the so-called apocalyptic prophets—Daniel, and some of Zechariah and Isaiah. Early Christian commentators were particularly attracted to the apocalyptic prophets and tended to read all the Hebrew prophets in a way that attributed to them the foretelling of future events, particularly predictions about Jesus.

According to the Gospel accounts of his life, Jesus not only saw his coming as a fulfillment of prophecy, but he also related aspects of his life to events described in Jewish scripture. Identifying himself as the Son of Man, he declared that "as Moses raised a serpent in the desert, so must the Son of Man be raised" (John 3:14), understood by Christians as a reference to his future Crucifixion. Similarly, Jesus alluded to his three days in the tomb before his Resurrection in the following terms: "As Jonah was three days and three nights in the belly of the great fish, so will the Son of Man be three days and three nights in the heart of the earth" (Matthew 12:40). Jesus' allusions to the familiar stories of Moses and Jonah from Jewish scripture lie at the root of the Christian theory of types, called typology.

Typology is the method of scriptural interpretation whereby persons or events in the Hebrew Bible—types—are seen to prefigure persons or events in the New Testament or the history of the Church. Although the etymology of the Greek word *typos* is complex, it allows for an understanding of typology in terms of the casting of sculpture. The type—the Old Testament person or event—is the mold, and the New Testament person or event is what the mold produces, i.e., the statue. There is a distinct hierarchy between the two, and it is the latter that is prized.

Christian ideas of prophecy and typology are based on the belief that the promise of Christian salvation—the deliverance of humanity from the penalty for sin—was present from the time of Creation. The stories and poetry of Jewish scripture, therefore, owe their significance to their role in salvation history. Early Christian commentators were eager to confirm this belief through their reading of the Old Testament.

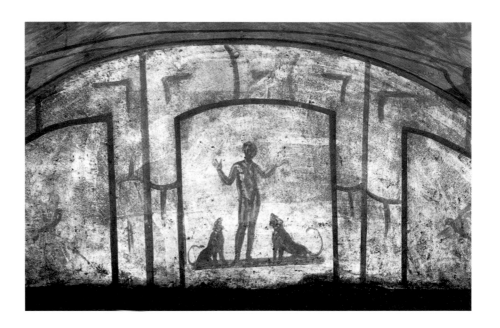

Saint Augustine, whose biblical commentaries were widely influential, summarized the theory as follows:

> For what is that which is called the Old Testament but the veiled form of the New? And what else is that which is called the New but the unveiling of the Old? (*City of God* XVI, 26)

According to Augustine, then, Old Testament persons and events prefigure persons and events from Christian history, and their meaning is necessarily veiled until explained in terms of salvation history.

Prophecy and typology had a formative influence on Christian art from its very beginnings. Old Testament types of resurrection are very common in the paintings that decorated the walls and ceilings of catacombs, the underground burial places of the earliest Christians. A vignette showing the prophet Daniel between two lions, for example, serves as a type both for Christ's Resurrection and for the resurrection of all the dead at the time of Judgment [FIGURE 31]. Daniel's miraculous deliverance from near-certain death in the lions' den is understood, therefore, to prefigure the

38

deliverance of the Christian believer from death. The story of Jonah and the great fish, cited by Jesus as a type of his Resurrection, is frequently depicted in Christian catacombs, and it is sometimes given narrative treatment in three or four scenes.

By the fourth century, picture cycles were created that mixed scenes from the Old and New Testaments. On a carved marble coffin now in the Vatican, for example, there is a curious mixture of Old Testament, New Testament, and other scenes [FIGURE 32]. Daniel in the Lions' Den is centrally placed and unquestionably functions as a type for the resurrection of the Christian couple whose remains the coffin contained. The carved wooden doors of the church of Santa Sabina in Rome are composed of panels illustrating scenes from the Old Testament and from the life of Christ, and some are paired to create typological juxtapositions. We also have written evidence from the early Middle Ages for lost cycles of paintings of Old and New Testament scenes arranged typologically.

Prophecy and typology were not only fundamental to Christian scriptural interpretation but also important for the development of the liturgy, the public ritual of the Church. Many of the chants sung by the

Figure 32
Scenes from the Old and New Testaments. Sarcophagus, Rome (?), circa 325–50. Marble, 131 × 267 × 145 cm (51⅝ × 105⅛ × 57⅛ in.), lid: 30 × 273 × 148 cm (11¹³⁄₁₆ × 107⅜ × 58¼ in.). Vatican City, Museo Pio Christiano (Inv. 104).

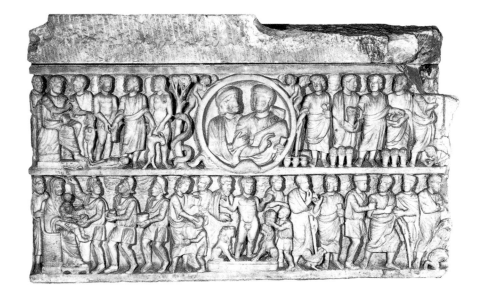

choir in the celebration of the sacraments and in prayer services have texts taken from or based on Jewish scripture, with the psalms playing a particularly important role. For example, at the feast of Epiphany, the annual commemoration of the visit of wise men from the East to the Christ Child, one of the chants has a text taken from Psalm 71:

> The kings of Tharsis and the islands will offer presents. The kings of
> the Arabians and of Saba will bring gifts (Psalm 71:10).

This passage was interpreted by the earliest Christian commentators in relationship to the Adoration of the Magi. Indeed, it was the interpretation of this psalm verse that led to the understanding, widespread by the end of the Middle Ages, that the "wise men" of the New Testament story were kings.

The Eucharist, the sacrament of the Mass in which bread and wine are consecrated and consumed, derives its name from the Greek word for "thanksgiving." Christian writers consistently associated the Eucharist with the Jewish tradition of sacrificial offerings, and a prayer recited by the celebrating priest as he prepares the bread and wine mentions three sacrifices in particular:

> Deem it worthy . . . to accept the immaculate host just as you deemed
> it worthy to accept the gifts of your righteous son Abel and the sac-
> rifice of our patriarch Abraham and the holy sacrifice that your high
> priest Melchizedek offered to you.

The prayer refers here to Abel's offering of the best lamb of his flock to the Lord (Genesis 4:4), to Abraham's willingness to offer his son Isaac as a sacrifice (Genesis 22:9–11), and to Melchizedek's offering of bread and wine (Genesis 14:18). Christian commentators interpreted these Old Testament sacrifices as types for the Crucifixion—Christ's sacrifice for the Christian faithful—which is commemorated in the Eucharist.

The association of the three patriarchs with the Eucharist finds its expression both in manuscript illumination and in the monumental

arts. In the sixth-century church of Sant' Apollinare in Classe, near Ravenna, for example, a mosaic shows Abel, Melchizedek, and Abraham grouped around an altar [FIGURE 33]. The image appears in the apse of the church, near the altar where the priest says the prayer. The subject is also found in religious service books. For example, tiny figures of Abel, Melchizedek, and Abraham—in this instance with an animal rather than his son Isaac—populate a full-page letter *T* that begins the Eucharistic prayers in the sacramentary of Drogo of Metz [FIGURE 34A].

Among early medieval scriptural—as opposed to liturgical—books, typology finds visual expression chiefly in manuscripts of the psalms. The two most extensively illuminated psalters of the ninth century provide characteristic examples. In the Stuttgart Psalter, the passage in Psalm 71 about the gifts of the kings of Tharsis, the Arabians, and Saba mentioned above is illustrated by a miniature of the Adoration of the Magi [FIGURE 35], which makes the Christian understanding of the verse explicit. The illustrations in the nearly contemporary Utrecht Psalter are very different in appearance from the miniatures of the Stuttgart Psalter, but the typological approach to the psalms is just as clearly in evidence. The drawing that heads Psalm 88 [FIGURE 36], for example, includes at the upper right a vignette of the Crucifixion, which illustrates verse 39:

> But you have rejected, and despised, and been angry with your anointed one.

The presence of the word *christus* (anointed one) in the Latin text of the psalm prompted, even compelled,

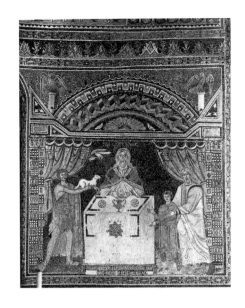

Figure 33
Old Testament Sacrifices. Church of Sant' Apollinare, Classe, mid-sixth century. Mosaic. Photo: Archivi Alinari-Firenze

Figures 34a–b
Initial *T* with *Old Testament Sacrifices*. Drogo Sacramentary, Metz, circa 844–55. Tempera and gold on parchment, 130 leaves, 26.4 × 21.4 cm (10 3/8 × 8 7/16 in.). Paris, Bibliothèque nationale de France (Ms. lat. 9428, fols. 15v–16).

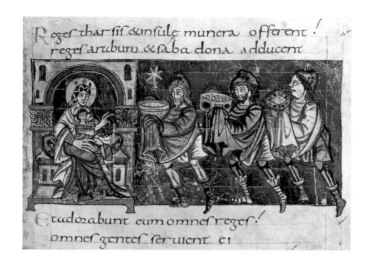

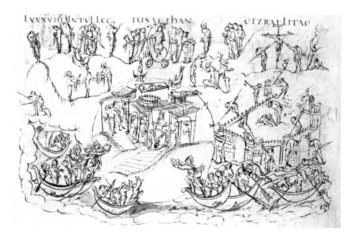

the understanding of this verse in connection with Christ's suffering at the Crucifixion. These are but two examples of the use of the visual medium to bring out a specifically Christian and typological interpretation of the psalms in this pair of manuscripts. Many more could be cited, especially from the Stuttgart Psalter, which points to the pervasiveness of typological thinking in medieval psalm commentary.

Whereas the pairing of typologically related Old and New Testament scenes can be found in the earliest Christian art, it was not until the

eleventh century that a comprehensive visual expression of the theory of typology itself was attempted. The fundamental Christian belief that the promise of redemption was present at the time of Creation is the subject of the monumental bronze doors made at Hildesheim at the behest of Bishop Bernward and completed in 1015 [FIGURE 37]. The reliefs on the left door present a series of scenes from Genesis, beginning with the Creation of Eve at the top and continuing chronologically to Cain murdering his brother Abel at the bottom. On the right door, scenes from the New Testament are arranged in a chronological sequence beginning with the Annunciation to the Virgin, at the bottom, and ending with Christ's appearance to Mary Magdalene after the Resurrection, at the top. The difference in the chronological arrangement—with the Genesis scenes proceeding from top to bottom and the christological scenes from bottom to top—is important. It articulates the Christian belief that human history takes a sinful, or downward, course that can only be reversed through the Incarnation, the embodiment of God in the human form of Jesus.

Although there is not a typological relationship between each pair of scenes, the episodes selected, the visual form they take, and their juxtaposition across the two doors all contribute to the meaning of the pictorial program. Decisive is the juxtaposition of Eve offering the forbidden fruit to Adam with the scene of the Crucifixion [FIGURE 38]. The symmetrical disposition of Adam and Eve on either side of the Tree of Knowledge is mirrored by the symmetrical composition of the Crucifixion image, highlighting the relationship between the two subjects. The pairing expresses the Christian view, vigorously promoted by Saint Paul, that Adam and Eve's defiance of the Lord's command not to eat the fruit inaugurated human sin, from which humanity is delivered through Christ's death on the cross. An important sub-theme of the doors is the typology of Eve and the Virgin Mary, which is brought out in part by the visual similarity and close proximity of Eve with the infant Cain to the Virgin with the infant Christ in the reliefs just above the door handles. The Hildesheim cathedral doors mark a turning point in the exposition of Jewish

45

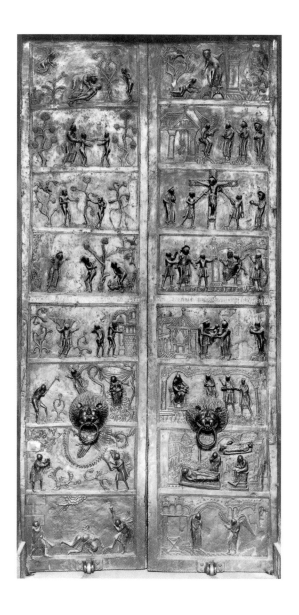

scripture in a Christian artistic context. The isolated vignette and the typological pairings of the early Christian period are replaced by a more exhaustive and nuanced presentation.

In the twelfth century, an intellectual movement emerged in Europe that sought to bring all human knowledge into comprehensive schemes. Biblical scholars were particularly interested in gathering and organizing the commentaries of early Christian writers and resolving any apparent inconsistencies among them. An influential manifestation of the new biblical scholarship is the *Glossa ordinaria*, a series of extracts taken mainly from early Christian commentators, which appears as a marginal and interlinear gloss to the Bible. Not only was the *Gloss* a new compilation, but its physical appearance in manuscripts also distinguished it from most earlier biblical commentary. The interpretive text, written in a smaller script than the main text, surrounds and is partially interwoven with the biblical text [FIGURE 39]. The information in the commentary was considered authoritative, to be sure, but the divine origin of the biblical text is visible through its large size and central placement.

The impulse to collect, organize, and reconcile knowledge is evident not only in scholarship but also in the visual arts of the twelfth century, and the wide circulation of the *Gloss* and its successors made a veritable encyclopedia of biblical commentary conveniently available. This inaugurates the golden age of typology and prophecy in Christian art. An early example of the new sort of typological art is found in a manuscript of excerpts from saints' lives made at Cîteaux in France in the early twelfth century. The miniature that introduces the reading for the feast of the Nativity of the Virgin shows the Tree of Jesse [FIGURE 40], a subject inspired by a prophecy of Isaiah:

> And there will come forth a shoot out of the root of Jesse, and a flower will grow out of his root (Isaiah 11:1).

Medieval Christians explained this enigmatic passage as a foretelling that Christ, the flower, would be born of the Virgin Mary, the shoot, who was

Figure 37
Scenes from Genesis and the Life of Christ.
Doors, Hildesheim, 1015. Bronze, H: 472 cm (185⅞ in.). Hildesheim, Cathedral.

Figure 38
Drawing after the Hildesheim cathedral doors [Figure 37].

47

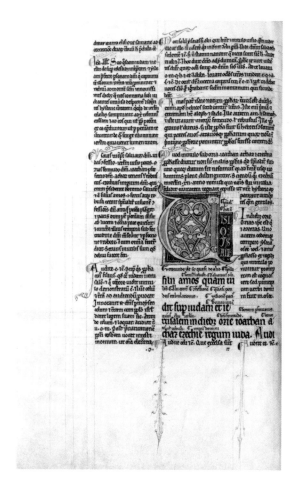

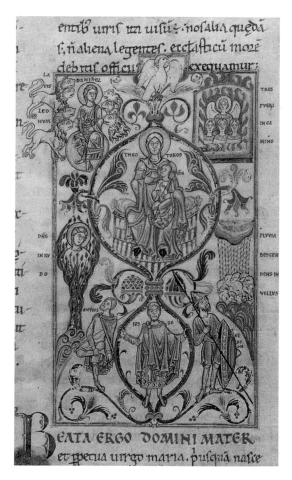

descended from the Jewish patriarch Jesse, the father of King David. This interpretation relied in part on the wordplay between *virga* (shoot) and *virgo* (virgin). Although there is no biblical authority for the claim that Mary was descended from Jesse, that patriarch is numbered among the paternal ancestors of Christ in the Gospels.

Isaiah's prophecy is pictured in the center of the miniature. Jesse is shown within a scrolling vine that appears to grow upward and which also embraces the enthroned Virgin, labeled *theotokos* (Greek for God-

bearer). She offers her breast to the infant Jesus. Four Old Testament types for the virgin birth of Christ are pictured in the corners of the composition: Daniel in the Lions' Den (Daniel 6:16–23), three Hebrew youths who were miraculously saved from near-certain death in a furnace (Daniel 3:15–24), the Lord appearing to Moses in a burning bush that is not consumed by the fire (Exodus 3:1–10), and Gideon with the miraculous fleece that is covered with dew when the ground around it is dry (Judges 6:36–40).

Unlike the Hildesheim cathedral doors, where the Old and New Testament scenes are given equal weight, a visual hierarchy governs this Tree of Jesse miniature. The Virgin is emphasized both by her placement in the center of the composition and by scale. Furthermore, the four ancillary scenes are arranged according to the Christian understanding of the periodization of Old Testament history. The two events that took place before Moses received the tablets of the Law (the period *ante legem*) are at the bottom, and the two that occurred after Moses received the Law (the period *sub lege*) are at the top of the miniature. In the composition as a whole, therefore, prophecy and typology are linked, and a rich range of associations is made between the Old Testament and the Christian belief in the virgin birth of Christ.

The hierarchical presentation in this miniature can be seen at once to mirror and to surpass the presentation of biblical commentary in manuscripts of the *Glossa ordinaria*. On the one hand, the Virgin and Child appear at the center of the composition and dominate the other elements, just as the biblical text in a glossed manuscript is at the center and larger than the commentary. In a sense, therefore, the miniature imitates the appearance of a page of the *Gloss*. On the other hand, in manuscripts of the *Gloss*, the Christian significance of Jewish scripture is generally explained in small script on the perimeter of the relevant Old Testament text. This situation is not mirrored in the miniature. Instead, the christological scene—the statue of our sculpture casting analogy—

Figure 41

*The Crucifixion and
Old Testament Sacrifices.*
Casket, lower Saxony,
circa 1170. Champlevé
and cloisonné enamel
and gilt copper on wood,
H: 5.4 cm (2⅛ in.).
Cleveland, Museum of Art
(1949.431). © 2000 The
Cleveland Museum of Art,
purchase from the J. H.
Wade Fund.

stands at the center of the composition and is surrounded by its types—
the mold or pieces of the mold of the casting analogy.

Some of the most characteristic twelfth-century artistic expressions
of typology are found in the figural decoration of metalwork objects in-
tended for use in connection with the liturgy of the Mass. These often
include a representation of the Crucifixion, together with one or more of
its Old Testament types. The Old Testament sacrifices mentioned in the
Eucharistic prayer cited above appear most frequently. Rarely, a narrative
sequence is accompanied by a series of Old Testament types. More com-
monly, a visual hierarchy governs these works, and the Crucifixion is larger
in scale than the Old Testament scenes, as on an enamel casket in the
Cleveland Museum of Art [FIGURE 41].

Another aspect of the art of the twelfth century is the incorporation of natural history into the body of knowledge exploited in the presentation of salvation history. A representation of a unicorn with its head in the lap of a woman, for example, might be shown together with the Nativity of Christ [FIGURE 42]. According to medieval bestiaries, the unicorn was extremely strong and could not be approached directly by a hunter, but it would rest its head in the lap of a chaste woman. The juxtaposition of the two themes illustrates the Christian belief that Jesus—God and man in one being (represented by the unicorn)—was the offspring of a virgin. Similarly, a lion might appear as a symbol for Christ's Resurrection three days after his death, based on the medieval belief that a lion cub first came to life when the father breathed life into it three days after its birth.

For the most part, the individual themes explored in the twelfth-century monuments of typological art were not new. The types represented were identified in the writings of the earliest Christian commentators and reflected the liturgy of the Church. Indeed, many of the Old Testament figures and scenes had previously appeared in artistic contexts where their typological significance was manifest. What distinguishes the Christian art of the twelfth century is the effort to embrace all human knowledge—including prophecy, typology, and natural history—into artworks that express Christian beliefs in an encyclopedic fashion.

Themes from Jewish scripture continued to be important in Christian art of the later Middle Ages

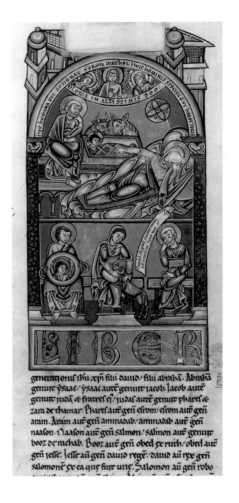

Figure 42
The Nativity. Floreffe Bible, Meuse valley, circa 1156. Tempera, gold, and silver on parchment, 256 leaves, 47.5 × 33 cm (18$^{11}/_{16}$ × 13 in.). London, British Library (Add. Ms. 17738, fol. 168, detail). By permission of the British Library.

and the early modern period. This is apparent, above all, in the popularity of two biblical commentaries of the late Middle Ages, the *Bible of the Poor* and the *Mirror of Human Salvation*. These commentaries circulated for centuries, first in manuscript and then in print, and featured individual scenes from the life of Christ presented together with Old Testament types. The influence of these books in artistic circles ultimately led, however, to a somewhat stale repetition of motifs, and the theological ambitiousness and visual sophistication of the twelfth-century monuments were rarely equaled in later centuries.

The Frontispiece
Miniatures

The Stammheim Missal is one of the consummate works of the golden age of typology and prophecy in Christian art. The program of the manuscript's miniatures unfolds as the pages are turned, presenting in visual form the theory of typology and the Christian view of prophecy while tracing the meaning of salvation for the Christian faithful in general and for the monks of Saint Michael in particular. The cycle of miniatures consists of twelve images: five frontispieces, five miniatures associated with feast days of the universal Church, and two miniatures associated with saints' feasts. Let us turn our attention now to a detailed examination of the manuscript's frontispieces.

The opening pair of frontispiece miniatures presents the theme of the Wisdom of Creation [FIGURES 43A–B]. On the left page, the Creator, flanked by seraphim, holds a disk on which the six days of Creation are represented in medallions. Each day is labeled ("first day," "second day," etc.) and accompanied by a brief inscription from Genesis describing the events of that day. This configuration relies on a tradition of visualizing the ordered cosmos as a circle. The medallion for the sixth day of Creation opens out into the middle of the disk, where the Creation of Eve is represented. This device allows the artist to depict both the animals and the first human couple, all created on the sixth day, with special emphasis placed on Adam and Eve, who occupy the center of the cosmos. At the bottom of the page, King David gazes

Overleaf
Figures 43a–b
The Wisdom of Creation.
Stammheim Missal
(fols. 10v–11).

53

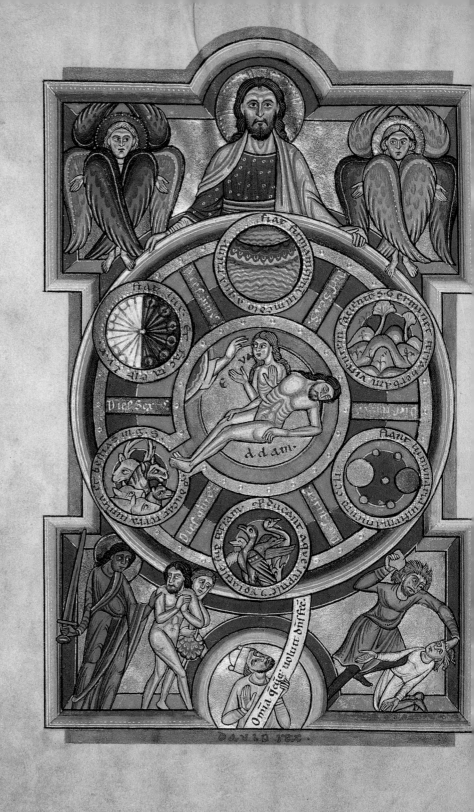

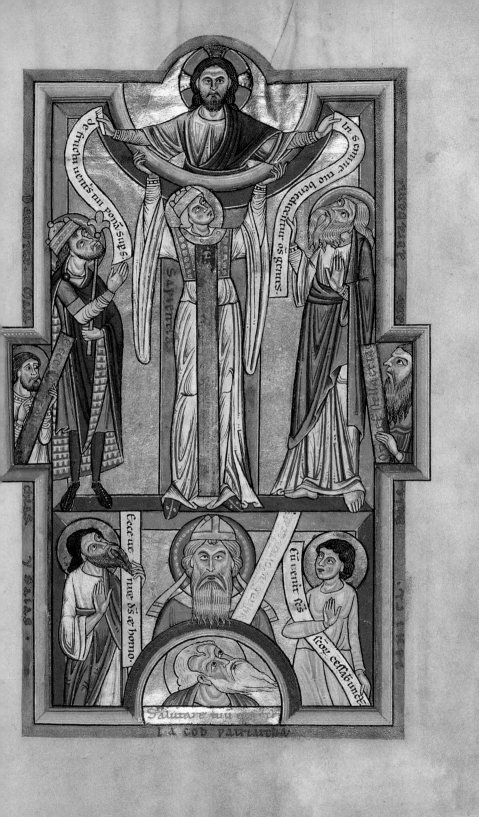

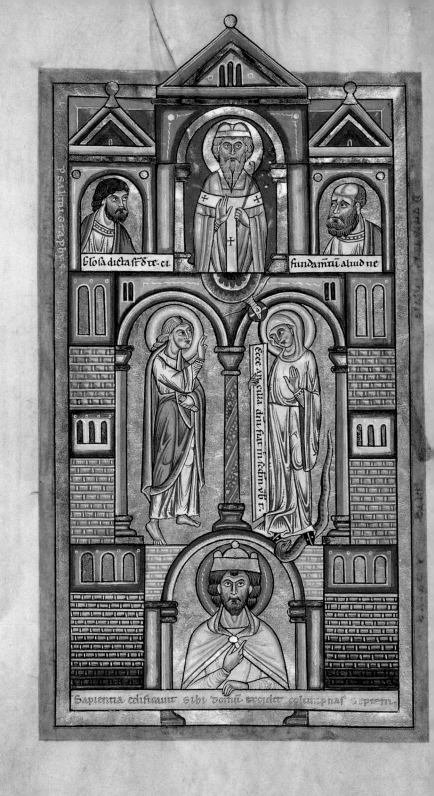

up at the scene and holds a scroll that proclaims "All that pleased the Lord, he did" (cf. Psalm 113:3 and Psalm 134:6). The story of early humanity continues in the lower corners of the miniature with the expulsion of Adam and Eve from paradise (on the left) and Cain killing his brother Abel (on the right). This pair of scenes emphasizes what Christian commentators understood to be the sinful course of human history. In the Christian view, human sin required the salvation that is promised in the image on the facing page.

The miniature on the right [FIGURE 43B] shows the Creator within the arc of heaven held aloft by the personification of Wisdom (*Sapientia*). Below her is the priest Zechariah, father of John the Baptist, and below him the patriarch Jacob. The Creator speaks to David and Abraham, who flank *Sapientia*. The remaining figures are Old Testament prophets.

The core of the composition—the Lord, *Sapientia*, Zechariah, Jacob—is an illustration of Ecclesiasticus 24:13, a text that does not appear in the miniature:

> And he [the Creator of all things] said to me [Wisdom]: Let your dwelling be in Jacob, and your inheritance in Israel, and take root in my elect.

The text on the figure of Wisdom identifies the figure above as the Creator: "I was with him forming all things" (Proverbs 8:30), and indeed the "forming [of] all things" is illustrated on the facing page. In the miniature, Wisdom is not merely "with him" but physically supports him, and the geometric regularity of the image as a whole emphasizes the firmness of Wisdom's support.

The miniature's composition is reminiscent of contemporary representations of the Tree of Jesse, a visualization of Christ's ancestry, such as the one in the Stammheim Missal [SEE FIGURE 45]. The figure of the Creator here takes the position of Christ, and *Sapientia* that of the Virgin Mary. The identification of the Creator with Christ is emphasized not only through this compositional device but also through the figure's cross-inscribed nimbus.

Figure 44
The Annunciation.
Stammheim Missal
(fol. 11v).

57

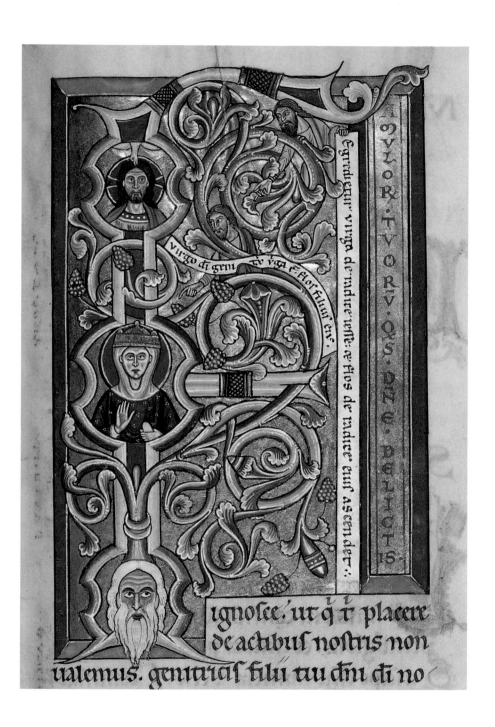

virgo di grii de vga e flor filui eni.

egrdietur virga de radice iesse. e flos de radice eius ascender.

A
M
V
L
O
R
·
T
V
O
R
V
·
Q
S
·
D
N
E
·
D
E
L
I
C
T
I
S
·

ignosce, ut q͞ t placere
de actibus nostris non
ualemus. genitricis filii tui d͞ni d͞i no

The linking of the Creator with Christ and of Creation with Christian salvation is elaborated in the texts within the miniature. The words below the figure of Jacob are taken from his cry to the Lord from his deathbed: "I will look for your salvation" (Genesis 49:18), understood by Christian commentators as a reference to the coming of Christ. The Creator says to David: "Of the fruit of your womb I will set upon your throne" (Psalm 131:11), and to Abraham: "In your seed shall all people be blessed" (Genesis 22:18). Since Jesus' ancestry was traced by Christian scripture to David and Abraham (Matthew 1:1), the Lord's words to them in the miniature were also interpreted as references to the coming of Christ. The prophets and Zechariah join Jacob in looking to the coming of the Messiah. Their scrolls include epithets often applied to Christ (for example, "Lord of Hosts" and "God and Man").

The image on the right-hand page [FIGURE 43B] is thus both an illustration of Wisdom's obscure soliloquy in Ecclesiasticus and, together with the facing miniature [FIGURE 43A], a visualization of the promise of Christian salvation that is inherent in Creation. The illuminator has cast the dual role of each miniature masterfully. While each presents a comprehensive and intelligible whole within a symmetrical composition, the exterior contour of the miniatures—the left indented and the right jutting out at the sides—suggests that, like pieces of a jigsaw puzzle, they are meant to fit together: their meaning only becomes complete with the joining of the two images.

The third miniature of the series immediately follows as one turns the page [SEE FIGURE 44]. This miniature, depicting the Annunciation, amplifies and at the same time makes more specific the themes of the wisdom of the Lord's Creation and the inherent promise of Christian salvation presented on the preceding two pages. The archangel Gabriel announces to the Virgin Mary that the Holy Spirit—represented as a dove in the miniature—would come upon her and she would bear the Son of God (Luke 1:35). The event takes place within an elaborate architectural structure that

represents at once the House of Wisdom, the abstract concept of the Church, and the city of God.

King Solomon is pictured at the bottom of the miniature. His scroll records one of his proverbs: "Wisdom built her house; she hewed out seven columns" (Proverbs 9:1). Indeed, seven columns can be counted as part of the fabric of the miniature's House of Wisdom, within which the Annunciation takes place. That this structure also represents the Church is signaled by the presence of Saint Paul at the upper right. His scroll alludes to his discussion of the metaphorical construction of the community of Christians—the Church—on the foundation that is Christ: "No one can lay other foundation" (cf. 1 Corinthians 3:11). The scroll held by King David, at the upper left, identifies the architecture also as the heavenly city of God: "Glorious things are said of you, city of God" (Psalm 86:3).

The figure between King David and Saint Paul is Aaron—the first in the dominant line of Jewish priests. The election of Aaron and his progeny to the priesthood was achieved through a miracle. The shoot of a branch assigned to Aaron miraculously blossomed, sprouting leaves that formed into almonds (Numbers 17:8). This miracle was understood by Christians to prefigure the Virgin's conception and bearing of Jesus—her fruit—while remaining a virgin. Thus Aaron with his flowering shoot appears here as a type for the annunciate Virgin, but he also represents the priesthood, which in turn points to the role of the Church in salvation history. This theme is further emphasized by the depiction of the Virgin both as the young woman who would bear Jesus and as a personification of the Church, trampling evil—shown as a serpent—under her feet.

The three-fold identification of the miniature's architecture encapsulates Saint Augustine's view of history: the events of this world—both those of Old Testament times and those of the Christian era—lead inextricably to the Second Coming of Christ, when he will judge all humanity from his heavenly throne. The Incarnation, the embodiment of God in Jesus, which is visualized in the Annunciation, was understood as a turning point in the course of this history. *The Annunciation*, therefore, rep-

resents the fulfillment of the prophecies of the coming of Christ and completes the meaning of the miniatures on the preceding two pages.

Taken together, the suite of three frontispiece miniatures, therefore, establishes the theological basis for the theory of typology and articulates the theme that the sinful course of human history requires the salvation brought through the Incarnation. Although many aspects of this theme were commonplaces of medieval thinking and can be found in the visual arts of the early Middle Ages, the Stammheim Missal's comprehensive statement is entirely unprecedented in surviving medieval manuscript illumination. Only one monument of antecedent art presents in a comparably complete way the theme of the missal's frontispieces: the Hildesheim cathedral doors [FIGURE 37] discussed in the previous chapter.

Bernward's doors surely provided inspiration for the frontispieces. The last episode in the Creation miniature—Cain murdering Abel—effects the transition to the miniature on the facing page. This is an echo of the relationship between the Genesis scenes and the christological scenes on the doors, where Cain murdering Abel is the scene at the bottom of the left door. Furthermore, in the missal's miniature showing Wisdom supporting the Creator [FIGURE 43 B], Jacob's head is turned so that his gaze is directed up toward the bust-length figure of Christ at the top. Indeed, most of the figures glance up, so that there is a sense of upward momentum within the miniature, much as the New Testament scenes on the right door at the cathedral proceed chronologically from bottom to top. Finally, the Annunciation—the subject of the last miniature in the sequence—identifies the key role of the Incarnation in salvation history, which is the theme of the doors. Although the illuminator of the missal has presented the theme in an original way in the miniatures, he has borrowed both content and compositional devices from Bernward's doors.

The next pair of full-page miniatures [FIGURES 46A–B] appears at the opening of the Eucharistic prayers. Although separated from the first three miniatures by the section of the manuscript containing the chants, they continue the missal's series of frontispieces. On the left-hand page

Overleaf
Figures 46a–b
Christ in Majesty;
The Crucifixion.
Stammheim Missal
(fols. 85v–86).

61

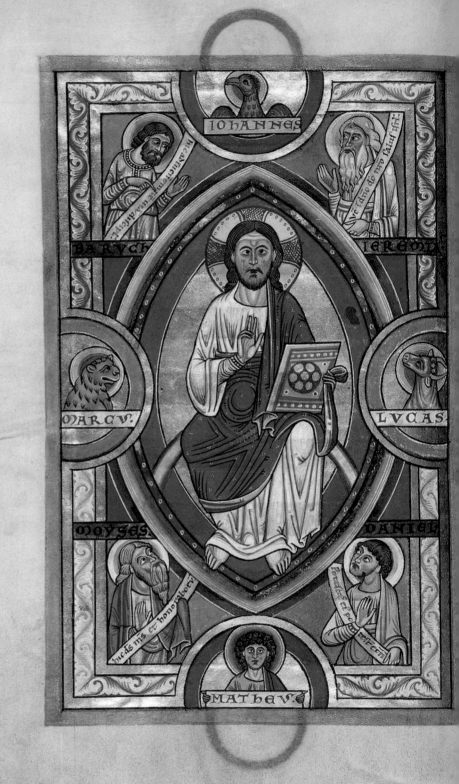

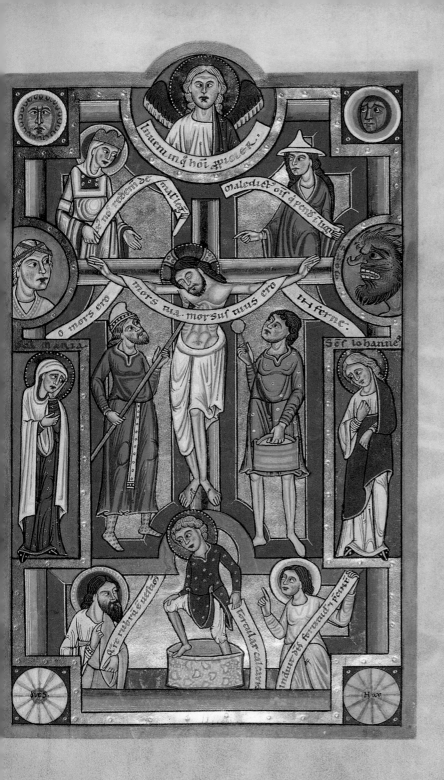

[FIGURE 46A], the illuminator shows Christ, his right hand raised in blessing, enthroned on a rainbow within an almond-shaped aureole. This is Christ of the Second Coming at the end of time.

The illuminator emphasizes the gravity of the theme through Christ's strict frontality, large halo, and transfixing stare, but the composition is also enlivened by the secondary figures. Four creatures, symbolizing the authors of the four Gospels, occupy half circles at the miniature's edges. Saint Jerome equated each author with one of the four living beasts described by Saint John the Divine in his account of the events at the end of time (Apocalypse 4:6–8): John with the eagle, Mark with the lion, Luke with the calf, and Matthew with the man. The arrangement of the creatures in the miniature reflects the medieval understanding of the special character of each of the Gospels. The man representing Matthew is shown at the bottom of the page because Matthew's Gospel begins with Christ's genealogy—his earthly roots—whereas the symbol of Saint John, thought through his visions to soar like the eagle, is pictured at the top of the page. The profile eagle and the frontal man strengthen the strong central axis created by the severe figure of Christ. The lion and the calf at the sides, however, twist their necks in order to face Christ.

At the corners of the composition, the Old Testament prophets and patriarchs Baruch, Jeremiah, Moses, and Daniel look and gesture toward Christ. They hold scrolls with texts that Christians understood as references to Christ. Daniel's scroll, for example, bears a quotation from his prophecy: "His power is everlasting power" (Daniel 7:14). The inclusion of the Old Testament figures in the image underlines the theme introduced in the manuscript's opening frontispieces—that Christ's deliverance of humanity from the punishment for sin at the Last Judgment was already guaranteed in Old Testament times.

The facing page [FIGURE 46B] shows the Crucifixion. Christ hangs from the cross in the center, while a soldier pierces his side with a lance and another man offers him vinegar on a sponge. The Virgin Mary and Saint John are pictured in separate compartments at the sides. The scroll draped

across Christ's body bears a text based on the prophecy of Hosea: "O death, I will be your death; hell, I will be your bite" (cf. Hosea 13:14). Medieval Christians understood this as a reference to Christ's having defeated death through his Resurrection. The theme of Christ's triumph over death is elaborated by the presence of the personifications of Life (*Vita*) and Death (*Mors*) in the semicircles near the arms of the cross. *Vita*, shown as a young woman, is at Christ's right, traditionally the side of the favored, and *Mors*, a hideous demon, is to Christ's left.

The miniature also presents the theme of the Church victorious over Jewish law. The personification of the Church, crowned and with a halo, is above the cross at Christ's right, and the personification of Synagogue, wearing a medieval Jew's hat, appears opposite. Synagogue's scroll reads: "All are cursed who hang from a tree" (cf. Deuteronomy 21:23), a reference to the Jewish practice of burying immediately after death anyone condemned to execution by hanging. Saint Paul understood Christ's death on the wood of the cross as a liberation from both this particular Jewish practice and, more generally, from Jewish law. His words on the subject are on the scroll held by the personification of the Church: "Christ has redeemed us from the curse of the law" (Galatians 3:13).

Below the Crucifixion scene, the prophet Isaiah, at left, asks a young man trampling grapes in a wine vat: "Why is your robe red?" The youth answers: "I have trodden the winepress alone." Both texts are derived from Isaiah's prophecy (Isaiah 63:2–3). Christian commentators equated the youth's treading of the winepress with Christ's washing away the sins of the world with his blood. The text on the scroll of the figure at the right emphasizes Christ's willingness to sacrifice himself for the faithful: "The Lord is clothed in strength and has girded himself" (cf. Psalm 92:1).

The Stammheim Missal's five frontispieces, embracing all of human history from Creation to the Last Judgment, clearly establish the context for the missal's feast miniatures, for which the manuscript is justly famous and to which we now turn our attention.

THE FEAST MINIATURES
AND SAINTS' MINIATURES

The first five miniatures within the section of the Stammheim Missal containing prayers of the Mass are associated with feasts celebrated during the course of the year—Christmas, Easter, the Ascension, Pentecost, and the Assumption of the Virgin. The subjects of these "feast miniatures" are presented in chronological order beginning with Christ's birth and ending with the death of the Virgin Mary. The miniatures bring together elements of typology, prophecy, and folklore in compositions involving up to fifteen figures. The final two miniatures, showing Saint Michael and Saint Bernward, respectively, although feast miniatures in the sense that they are associated with the liturgical celebration of each saint's feast day, are rather different in character from the preceding five.

A miniature of the Nativity of Christ [FIGURE 47] introduces the prayers for Christmas. The Virgin Mary reclines at the center of the composition. Above her, the swaddled infant Jesus lies in a manger—a trough from which animals are fed. An ox and an ass peer down at the baby. Their presence at Christ's birth is not attested in scripture but has a long visual tradition and was interpreted as a fulfillment of a prophecy of Isaiah: "The ox knows its owner, and the ass its master's crib" (Isaiah 1:3). Joseph, Mary's husband, is in the compartment to the right of her, and the prophet Ezekiel is at the left. Ezekiel points to a locked door below the Virgin, and his scroll includes a quotation from his prophecy: "This gate will be closed" (Ezekiel

Figure 47
The Nativity. Stammheim
Missal (fol. 92).

66

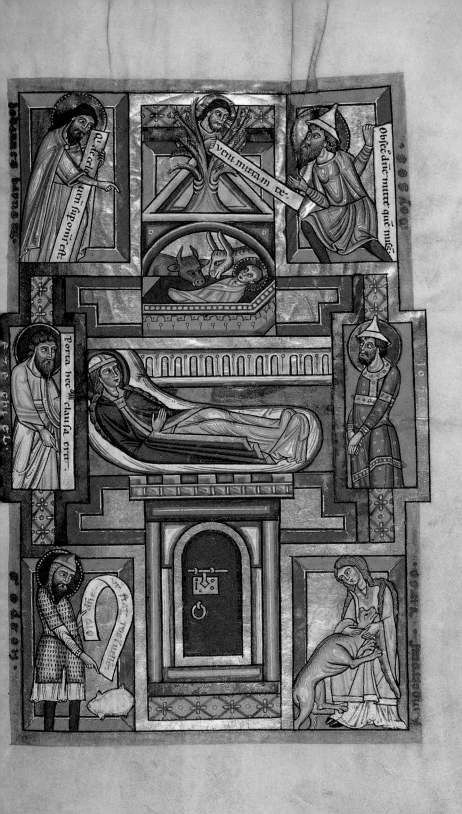

44:2). Saint Ambrose interpreted the gate of Ezekiel's prophecy as Mary, whose virginity remained intact although she bore Jesus.

The vignettes at the top of the miniature develop the theme that the newborn comes as the Savior of humanity. John the Baptist, at upper left, points to the infant. His scroll records his words regarding Jesus: "He who comes from heaven is above all" (John 3:31), a reference to Jesus as the Son of God. At the right, Moses kneels before the Lord, who appears to him within a burning bush that is not consumed by the fire. The Lord tells Moses that he is to lead the Israelites: "Come, [and] I will send you" (Exodus 3:10). Moses accepts his leadership role: "I beseech [you], Lord, send whom you will send" (Exodus 4:13). Christ, too, will unquestioningly accept his position as Savior of the faithful. In addition to its role in the narrative scene involving Moses, the burning bush, like the closed gate below, appears here as a type for the virgin birth.

The scene at the lower left is of the Old Testament warrior Gideon with a fleece that becomes wet miraculously while the ground surrounding it remains dry (Judges 6:36–40), understood as a type for Mary having conceived Jesus while remaining a virgin. At the lower right, a unicorn rests its head in the lap of a virgin, understood as a reflection in nature of the belief that a virgin bore Christ (God and man in one being).

The miniature for Easter Sunday [FIGURE 48] treats the theme of Christ's Resurrection. Two women approach Jesus' tomb three days after his Crucifixion in order to anoint the body. An angel tells them that he is not there: "Jesus whom you seek is not here but risen" (cf. Mark 16:6). The artist shows Christ bursting through the roof of the tomb. There he is greeted by the hand of God with the words "Arise, my glory," taken from Psalm 56. Christ answers with the closing of the psalm verse: "I will arise early." Saint Augustine interpreted this exchange allegorically in terms of the Resurrection, citing Saint Mark, who reports that the women went to the tomb very early in the morning. At the left are pictured the guards who have fallen asleep during their watch. Opposite them, the prophet Isaiah points to the

68

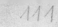

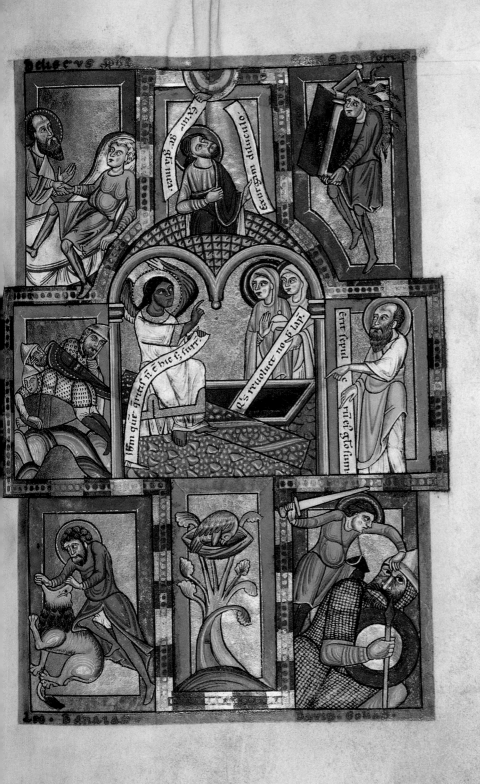

MOYSES · HELIAS ·

Sic aqla puocas ad v.

Ecce ego uobiscu sum oms diebus.

Dne ne derelinquas nos orphanos.

Mirax et misisum patris innos spm uer.

ascendit ds in iubilacione.

EZECHIEL · PSALMIGRAPHUS · ENOCH ·

empty coffin. His scroll is inscribed with a passage from his prophecy: "His sepulchre shall be glorious" (Isaiah 11:10).

In the four corners of the composition are four Old Testament scenes. They relate to both aspects of the Easter commemoration—Christ's descent into the underworld during his three days in the tomb and the Resurrection itself. Although Christ's death was understood to offer deliverance from sin for those who believed in his divinity and participated in the Christian sacraments, a separate rescue was required for the ancient Jews, which occasioned Christ's descent into the underworld. Banaiah slaying a lion in a pit of snow (2 Kings 23:20), at the lower left, and Samson carrying off the gates of Gaza (Judges 16:3), at upper right, prefigure Christ's descent and his breaking the gates of Limbo to rescue the worthy heroes of the Old Testament. Elisha raising the son of a Shunammite from the dead (4 Kings 4:32–37), above at left, and the familiar story of David and Goliath (1 Kings 17:51), at the lower right, are types of Christ's triumph over death through the Resurrection. The vignette in the center at the bottom shows the phoenix. Medieval treatises on animals explain that the phoenix sets itself alight, burns to death, and then rises from the ashes, a phenomenon always interpreted in relationship to Christ's Resurrection.

The central scene of the Ascension miniature [FIGURE 49] shows Christ's bodily ascent into heaven forty days after his Resurrection (Acts 1:9–11). Christ floats gently aloft in an almost dance-like pose as he looks down tenderly at the Virgin Mary and reaches his hand out toward her in blessing. The illuminator stresses the special relationship between Christ and his mother by showing them dressed identically in yellow tunics and patterned blue mantles.

The apostles are gathered to either side, their hands raised in gestures of amazement. Christ assures them of his continued spiritual presence among them despite his ascent into heaven: "Behold I am with you all days" (Matthew 28:20). They respond, asking for guidance in their future evangelizing: "Send the promise, the spirit of truth, from the Father into us" (cf. John 15:26). The brightly colored block beneath Christ's feet

71

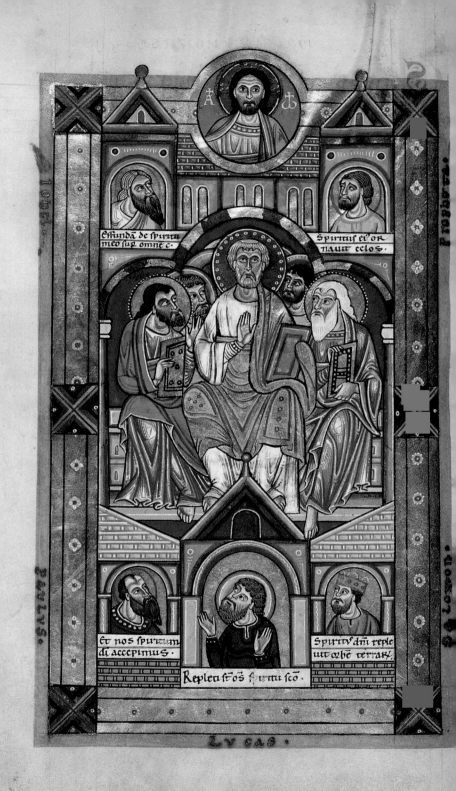

represents a stone believed by the Christian faithful to bear his last footprints on earth. Directly below Christ, King David points up toward the ascending figure, his gaze and gesture balancing those of Christ above.

Four Old Testament prefigurations of the Ascension are placed in the corners. At the upper left is an illustration of a passage from the Canticle of Moses in which the Lord is described as having lifted up the patriarch Jacob as the eagle entices her young to fly (Deuteronomy 32:11). Moses looks on as the eaglets are coaxed from the nest. Christian commentators equated the mother eagle's encouragement of her eaglets with the Lord urging Christ to join him in heaven. The vignette at the lower left comes from the prophecy of Ezekiel, who proclaimed that the prince of Israel would be lifted on the shoulders of men (Ezekiel 12:12).

At the upper right, the prophet Elijah is taken up to heaven in a chariot of fire (4 Kings 2:11), and, at the bottom right, Enoch is lifted to heaven after having lived 365 years (Genesis 5:23–24). Saint Gregory identified Enoch and Elijah as forerunners of Christ and explained that, while they were carried up to the aerial heaven, Christ by his own power penetrated the ethereal heaven.

A scene of Saint Peter preaching within an architectural structure [FIGURE 50] illustrates the feast of Pentecost, the commemoration of the descent of the Holy Spirit on the apostles after Christ's ascent into heaven. After being filled with the Holy Spirit, the apostles began to preach in a variety of languages. Saint Peter then explained the cacophony to the assembled people. The subject of the miniature is Peter's sermon (Acts 2:14–36).

Saint Luke, who describes both the descent of the Holy Spirit and Peter's sermon in the Acts of the Apostles, is pictured at the bottom of the page with a quotation from his account: "They were all filled with the Holy Spirit" (Acts 2:4). He looks up toward the figure of Saint Peter, seated together with a group of apostles at the center of the image. Peter raises his right hand in a gesture of speech, while he holds a book, representing the Gospel, in his left hand, which, in reverence, is covered by his mantle.

Figure 50
Saint Peter Preaching.
Stammheim Missal
(fol. 117v).

73

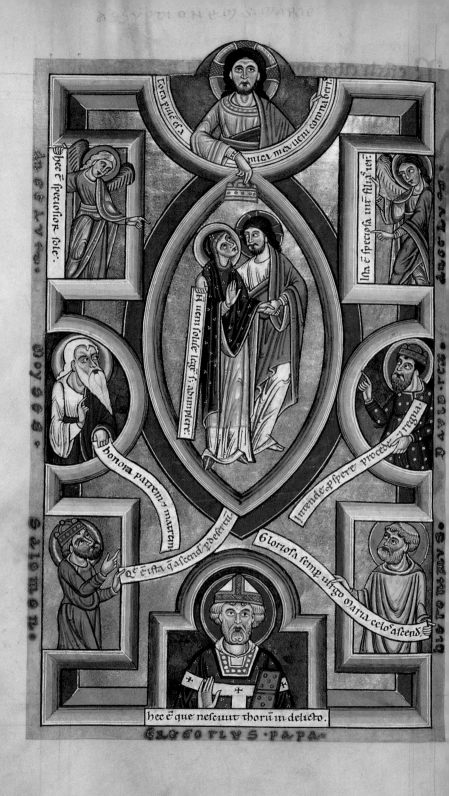

Tota pulc̄ es.

Amica mea ueni coronaberis

Hec ē speciosior sole.

Ista ē speciosa uñ filias ier̄

ANGELVS·

ANGELVS·

R̄ ueni solue legē sī adimplere

MOYSES·

DAVID REX·

honora patrem 7 matrē

Intende et psperē procede 7 regna

Q̄ ē ista q̄ ascend̄ p̄ deserti

Gloriosa semp uirgo ō aria celos ascend

SALOMON·

HIEROMAS·

hec ē que nesciut thorū in delicto·

The subject of Peter's preaching is pictured above him: Christ between an alpha and an omega, the first and last letters of the Greek alphabet, a motif that represents God's eternity. Peter's sermon describes Jesus as Lord and Christ, destined to reign in heaven until the end of time. Joel, whose prophecy Peter quotes in his sermon, is pictured at the upper left. The Old Testament figure Job (upper right), Saint Paul (lower left), and King Solomon (lower right) join him. Each man is accompanied by a text understood by Christians to refer to the Holy Spirit: "I will pour out from my spirit on all flesh" (Acts 2:17; cf. Joel 2:28); "His spirit adorned the heavens" (Job 26:13); "And we receive the spirit of God" (cf. 1 Corinthians 2:12); "The spirit of the Lord filled the whole world" (Wisdom 1:7).

Taken together the miniature's inscriptions express the Christian idea that the Holy Spirit fills the whole world and the heavens. In his sermon, Peter promises that the faithful who do penance and are baptized will be filled with the spirit, which is poured forth by Christ in heaven. The miniature's golden frame can be seen to represent the spirit, emanating from Christ in the medallion above and embracing all the figures.

The prayers for the feast of the Assumption of the Virgin (August 15) are introduced by a full-page miniature that shows the Virgin, accompanied by Jesus, floating gracefully within an almond-shaped aureole toward the Lord above, who is poised to crown her [FIGURE 51]. This is an image of the ascent of Mary's soul to heaven at her death, the event commemorated at the feast of the Assumption. It also represents the mystical union of the Church with Christ, a theme introduced into Christian theology by Saint Paul and emphasized in the liturgy for the feast of the Assumption.

The text on the scroll held by the Lord at the top of the miniature is based on a passage in the Old Testament book of the Song of Songs, a love poem in the form of a dialogue, which both Jewish and Christian commentators have understood as an allegory of the love of God for the faithful. The Lord says to Mary: "You are all beautiful, my love, come, and be crowned" (cf. Song of Songs 4:7–8). This text, together with the crown held by the Lord, emphasizes that Mary's Assumption begins her reign

75

as Queen of Heaven. The angels flanking Mary and Jesus, like the Lord above, declare the beauty of the Virgin with passages based on Old Testament wisdom literature: "She is more beautiful than the sun" (cf. Wisdom 7:29) and "You are beautiful among the daughters of Jerusalem" (cf. Song of Songs). That the beauty spoken of here is Mary's perpetual virginity is made clear by the text held by Saint Gregory at the bottom of the page: "This is she who has not known the bed of sin" (antiphon for Marian feasts, cf. Wisdom 3:13). Mary's motherhood, however, is implied by the figure of Moses pictured with a long white beard at left. His scroll bears the commandment to honor one's mother and father. Christian commentators explained that the Virgin held a special place in heaven because Christ followed the commandment and gave special honor to his mother.

Mary appears here not only as the mother of God, but also as a personification of the Church—the embodiment of all the Christian faithful—and the bride of Christ. The identification of the Virgin as Christ's bride is ultimately based on the Christian understanding of the Song of Songs. The illuminator has stressed the bridal association of the Virgin and Christ through their clasped hands and through Christ's tender gaze and protective embrace. For the Christian faithful, the union of Mary and Christ as bride and bridegroom represents the promise that the souls of all Christians will be united with Christ at the end of time. The scroll held by Christ comments on the relationship between Judaism and Christianity: "I come not to destroy the law but to fulfill it" (cf. Matthew 5:17). The mystical marriage of the Church and Christ is thus presented as the fulfillment of Jewish prophecy.

King Solomon, at the lower left, asks: "Who is she who goes up by the desert?" (Song of Songs 3:6). King David, at center right, adds: "Set out, proceed prosperously, and reign" (Psalm 44:5). This enigmatic exchange is based on the Christian allegorical interpretation of both the Song of Songs and Psalm 44 in terms of the marriage of Christ and the Church: she who goes up by the desert is the Church, who reigns eternally in heaven. At the lower right, Saint Jerome, shown in monk's robes, asserts

Figure 52
Saint Michael.
Stammheim Missal
(fol. 152).

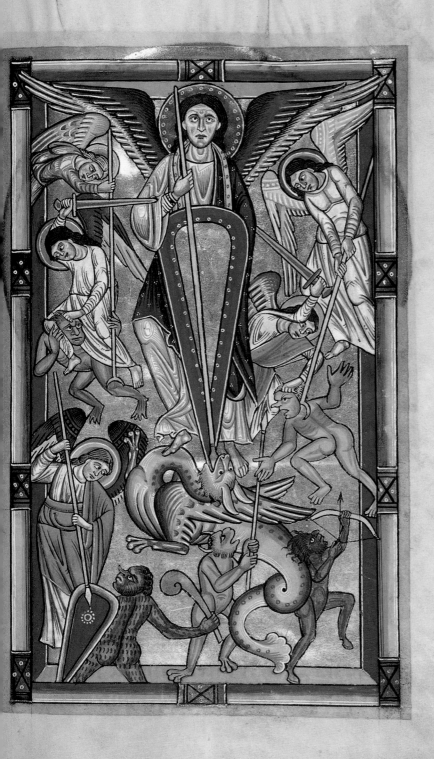

the Virgin's special status and confirms the infinite duration of the union of the Church with Christ: "Always glorious, the Virgin Mary ascended into the heavens" (from the pseudo-Jerome letter to Paula and Eustochium on the Assumption).

The feast of Saint Michael the Archangel (September 29), which commemorates the consecration of a church erected in his honor in Rome, is illustrated by a miniature showing Michael's battle with a dragon [FIGURE 52]. This battle is described in the Apocalypse, Saint John the Divine's account of events leading to the end of time:

> And there was a great battle in heaven. Michael and his angels fought with the dragon. And the dragon and his angels fought, but they did not prevail, and their place was no longer found in heaven (Apocalypse 12:7–8).

The text goes on to explain that the dragon is Satan—an embodiment of evil. The illuminator shows Michael spearing the dragon as smaller angels around him do battle with the "angels" of the dragon, represented as demons.

The illuminator portrays the ferocity of the struggle through the complicated interaction, tortuous poses, and various weapons of the smaller figures. There is no doubt as to the outcome, however, as Michael's upright form contrasts with the defeated dragon, whose body is doubled back on itself. The miniature records the triumph of good over evil implied by the narrative of the Apocalypse, but it is also a compelling portrait of the archangel, the patron saint of the monastery in Hildesheim. By organizing his composition so that the smaller figures represent the struggle of the battle, the illuminator is able to present a monumental image of the monastery's patron saint.

The prayers for the feast of Saint Bernward of Hildesheim (November 20) are prefaced by a miniature that draws particular attention to the saint's role as protector of the monks of his monastery [FIGURE 53]. Bernward, dressed in the vestments of a bishop, is shown within an archi-

Figure 53
Saint Bernward of Hildesheim. Stammheim Missal (fol. 156).

78

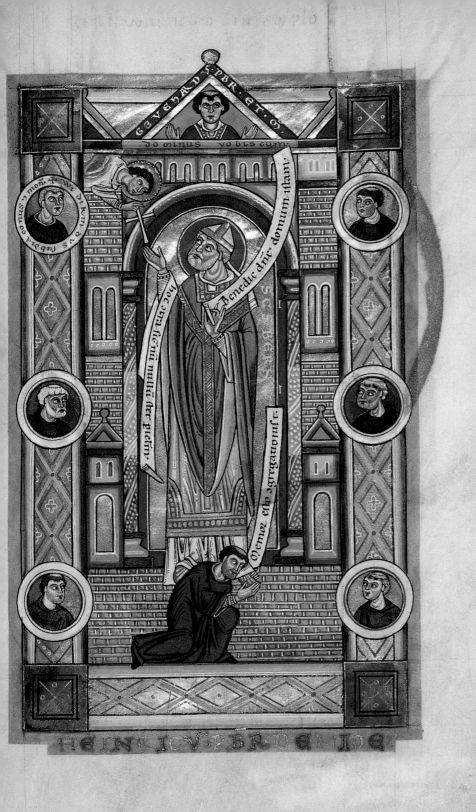

tectural structure that represents the monastery church of Saint Michael, which was built at his behest. An angel gives him a small cross, which may represent a piece of the cross on which Jesus was crucified that was given to Bernward by Emperor Otto III. The text on the scroll over Bernward's arm extols the protective power of the relic and of the sign of the cross: "No danger endures before this sign" (from a hymn attributed to Heribert of Eichstadt).

Above Saint Bernward in the gable of the architecture is Gevehard, labeled as monk and priest. He pronounces the blessing inscribed underneath him: "May the Lord be with you." Heinrich of Midel kneels before Bernward, caresses his foot, and entreats: "Remember your congregation" (Psalm 73 : 2). Bernward answers his prayer: "Lord, bless this house" (versicle for the Dedication of a Church). Gevehard and Heinrich of Midel were both contemporary monks of Saint Michael who were probably directly or indirectly involved in the production of the manuscript. The six monks shown in medallions at the sides of the miniature represent the monastic community—the "congregation" of Heinrich's plea. Of the six, only the monk at the upper left, Widekind, is labeled. It may have been intended that the other medallions would eventually be inscribed with the names of future monks.

The monk Gevehard, at the top of the miniature, is dressed in the vestments of a priest and thus plays a role in this scene comparable to that of Aaron in the miniature of the Annunciation [FIGURE 44]. Aaron represents the Jewish roots of the Christian priesthood, and Gevehard its continuation beyond biblical times into the present. This link between the manuscript's final miniature and the image of the Annunciation from the opening suite of frontispieces underlines that Bernward's role as protector of his congregation is like that of Christ for all the Christian faithful.

During the course of the series of feast miniatures, the focus shifts from events connected with the life of Jesus to the establishment and eternal reign of the Church. The first three images [FIGURES 47–49] address the turning points in Christ's earthly life—birth, Resurrection,

and ascent into heaven. Each of these miniatures emphasizes the certainty of the central event through the inclusion of a number of Old Testament figures understood as holding a prophetic or typological relationship to the christological scene. The miniature for Pentecost [FIGURE 50], showing Saint Peter preaching after the descent of the Holy Spirit upon the apostles, marks the dissemination of Jesus' teachings to a population who did not know him personally—the practical beginnings, that is, of the Church. The miniature for the feast of the Assumption [FIGURE 51] presents both the ascent of the Virgin's soul into heaven at her death and the mystical marriage of Christ and the Church, focusing attention on the Church's role into the future and on the Christian faithful's ultimate union with Christ.

Although the miniatures of Saint Michael and Saint Bernward [FIG-URES 52 AND 53] are not single-figure compositions, they nevertheless serve as portraits of the saints. The miniature of Saint Michael addresses a broad Christian theme, the triumph of good over evil, but it is also an arresting portrait of the monastery's patron saint. The Bernward miniature, the final one in the missal, emphasizes the saint's role as protector of the monastic community he founded.

The Pictorial
Program

The program of the miniatures in the Stammheim Missal—including the frontispieces, the feast miniatures, and the saints' miniatures—moves from the exposition of the basis for the theory of typology to the exploration of individual Christian themes in typological terms to saints' images of particular resonance for the monks of Saint Michael. To be sure, the sequence of images was determined by the structure of the manuscript's texts, which in turn was dependent on the liturgical calendar. Nevertheless, the illuminator has used the scaffolding supplied by the text to create an original and coherent pictorial statement, proceeding from the general to the specific and extending from the beginning of time to the twelfth century.

Figures, events, and texts from Jewish scripture appear at virtually every turn in the picture cycle of the Stammheim Missal. In *Christ in Majesty* [FIGURE 46A], for example, Christ of the Second Coming is accompanied not only by the symbols of the four evangelists, as was common in medieval art, but also by four Old Testament figures. Similarly, the miniature of the Crucifixion [FIGURE 46B]—the traditional subject to introduce the Eucharistic prayers in liturgical manuscripts—includes the unusual scene of Isaiah's prophecy concerning the boy who treads the winepress. It is the five miniatures associated with the feasts of the universal Church [FIGURES 47–51], however, that are the most remarkable in their presen-

tation of a great number of figures and themes within compositions that nevertheless maintain a strong focus on a single event in Christian history.

The secondary themes and figures of the five feast miniatures include Old Testament narrative scenes and depictions of prophecies as well as two vignettes illustrating animal lore. There are also individual figures of prophets, patriarchs, biblical and early Christian writers, and saints. There is no question as to the identity of these many themes and persons, because virtually all are labeled. Furthermore, many of the figures hold scrolls on which are inscribed texts attributed to them. Each of the miniatures is different in its particular configuration, and each draws upon biblical commentary and folklore in a slightly different way. Nevertheless, all are witness to the twelfth-century interest in collecting and ordering human knowledge in clearly legible schemes. Furthermore, in each miniature, as in many contemporary typological works of art, there is a clear hierarchy between the christological scene—the statue of our sculpture-casting analogy—and the Old Testament types—the mold, or perhaps pieces of the mold, of the casting analogy.

Each feast miniature has a system of frames within frames that helps to articulate its theme and works together with the relative scale of the figures to establish the hierarchy of elements within the image. In *The Women at the Tomb*, for example, each vignette has its own frame but also has a place within the larger framing scheme [FIGURE 54]. A gold and silver frame encloses the central scene of the holy women's encounter with the angel at Christ's tomb. It extends beyond the main rectangular frame at the sides but is held within it at top and bottom, so that the primacy of the central scene is clear without losing the integrity of the whole. Furthermore, the system of frames draws a distinction between the Old Testament narrative scenes (which are in the four corners of the miniature and excluded from the gold and silver frame) and the non-narrative secondary figures (the prophet Isaiah and the phoenix, which are embraced by the gold and silver frame).

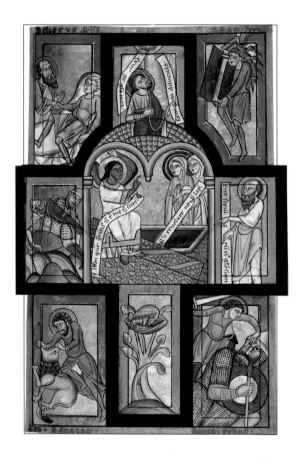

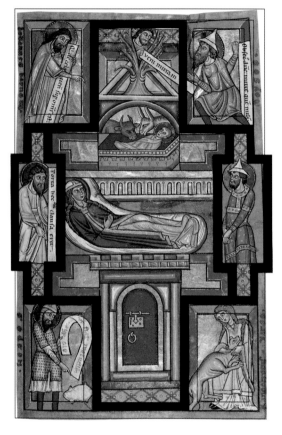

The framing schemes themselves are ingenious, and the illuminator often uses the gestures of the figures together with the frames to establish subtle relationships among parts of the miniatures. In *The Nativity*, for example, a thin gold frame encloses the central scene of the infant Jesus and the reclining Virgin Mary, together with the two types for the virgin birth—the bush that is not consumed by fire, at the top, and

the closed gate of the prophecy of Ezekiel, at the bottom [FIGURE 55]. Also included within this gold frame are the figures of Ezekiel and the Virgin's husband, Joseph. These two figures, however, are separated from the central group by thin silver framing elements, a device that serves to focus attention first and foremost on the Christian mystery of the virgin birth. Ezekiel's pointing gesture encourages the viewer to understand the relationship between him and the image of the closed gate, while Joseph's clasped hands betray that he was not involved in the conception of the child.

The framing schemes are instrumental in creating comprehensible images, but the illuminator never allows those schemes to become so rigid that the miniatures lack vitality. Furthermore, the relationship of figures to frames varies, with heads and feet often overlapping a framing element. The placement of a figure with respect to the frame may also serve to underline the meaning of an image as a whole. For example, King David at the bottom of the Ascension miniature appears to rise up from the frame, his body swaying as he points to the ascending Christ above him [FIGURE 56]. The position of the figure, therefore, contributes to the sense of upward movement in the miniature. Furthermore, the curve of David's body is mirrored in the curve of Christ's body above. Finally, David's pointing hand enters the space of the Ascension scene, which helps to draw the connection between the two figures. Indeed, the position of David in relationship to the frame suggests Christ's Resurrection from his tomb as pictured in the preceding miniature, which further links the two figures and suggests a progression between Christ's Resurrection and his later ascent into heaven.

The cycle of miniatures in the Stammheim Missal is a unique expression of Christian beliefs, and the visual medium is essential to that expression. Let us look closely, for example, at *The Women at the Tomb* [FIGURE 57]. The principal scene, in the center of the composition, is the exchange between two women and an angel at Jesus' tomb on the third day after his death. Isaiah, whose prophecy relates to the sepulchre in particu-

lar, is the Old Testament figure depicted closest to Christ's empty tomb. Each of the Old Testament vignettes in the corners bears a direct and equal spatial relationship to the central scene, just as each type bears an equal allegorical relationship to the New Testament event. This network of relationships cannot be expressed with the written or spoken word, where the presentation is necessarily sequential.

The particular configuration of the Old Testament scenes in the miniature—with types of the Descent into Limbo at the lower left and upper right, and types of the Resurrection at the upper left and the lower right—creates an "intersection" of these two aspects of the Easter celebration within the image. Yet another meaningful axis is established through the placement and pose of the phoenix. The illuminator shows the phoenix in the process of raising its head, a process that is completed metaphorically by the half-length figure of the risen Christ, whose head is turned upward. Although these relationships can be described in prose, their natural expression is in visual terms, and, indeed, their only complete expression is in the miniature itself. No writer—whether medieval Christian biblical scholar or the author of this book—can articulate the miniatures' themes with the force and clarity of the images themselves.

Subtle visual interrelationships such as those in the Easter miniature just described abound throughout the missal's imagery, but such compositional features are not the only way in which the visual medium is essential to the creation of meaning within the images. In the Ascension scene [FIGURE 49], for example, the special bond between Christ and his mother is shown through the tilt of his head toward her and even more forcefully through their identical garments. Similarly, in the Crucifixion miniature [FIGURE 46B], the association of Christ's blood with the grapes of wrath that stained the youth's garment of Isaiah's prophecy is emphasized by the blood and the robe being painted in the same red color. Frames, composition, pose, gesture, pattern, and color work together throughout the missal to create its theological statement.

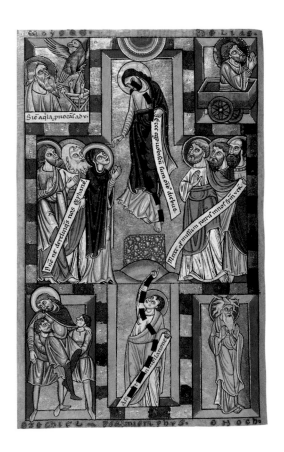

Figure 56
The Ascension [see Figure 49]. Stammheim Missal (fol. 115v).

Figure 57
The Women at the Tomb [see Figure 48]. Stammheim Missal (fol. 111).

The individual typological and prophetic relationships contained in the Stammheim Missal's miniatures—like those in most typological art of the twelfth century—had been identified by early biblical scholars, and many had become commonplaces of medieval Christian writing. No medieval author, however, had ever assembled the range of associations contained in the missal's pictorial program. The broad arc of salvation history from Creation to the Last Judgment is addressed, and key events of Christ's earthly life and other Christian themes are presented together with a rich range of associations from Jewish scripture and natural history. The illuminator's genius lies in his ability to present the complex theology of the pictorial program with consummate clarity. The details, engaging though they are, never overwhelm the visual hierarchies that articulate so forcefully the Christian understanding of the relationship of Jewish scripture to Christian doctrine. The final two miniatures turn the monks' attention from salvation history to their patron saint and then to their founder and themselves. The salvation that is promised to all the Christian faithful is pledged to them, who enjoy Saint Michael's protection and who beseech Saint Bernward to intercede on their behalf.

SUMMARY DESCRIPTION
OF THE STAMMHEIM MISSAL

Los Angeles, The J. Paul Getty Museum, Ms. 64

184 parchment leaves; 1^5, $2-10^8$, 11^4, $12-23^8$, 24^7 (gatherings 2 through 7 are numbered Ius, IIus, IIIus, IIIIus, Vus, VIus). Each leaf: 28.2 × 18.8 cm (11 1/8 × 7 7/16 in.). Ruled area 20.5 × 11.5 cm (8 1/8 × 4 1/2 in.), varies slightly. Latin text written in 32 long lines (fols. 3v–9), in 25 long lines (fols. 12v–60 and 83–185v), and in 29 lines in two columns (fols. 60v–82v).

Tempera, gold, silver, and ink on parchment bound between wood boards covered with alum-tawed pigskin. Twelve full-page miniatures; ten historiated initials; thirty-seven large and hundreds of small decorated and inhabited initials; three decorated incipit pages; twelve calendar pages with painted arches, zodiacal signs, and bust-length figures; twenty-nine pages with painted arcades.

PROVENANCE: Saint Michael, Hildesheim; Franz Egon, Freiherr von Fürstenberg (1737–1825), prince-bishop of Hildesheim and Paderborn, after the suppression of the monastery on February 18, 1803; by descent to Franz Egon's nephew Theodor, Freiherr von Fürstenberg (d. 1828), in 1825; Gräflich von Fürstenberg'sche Bibliothek zu Stammheim; by descent to Dietger, Freiherr von Fürstenberg.

EXHIBITION HISTORY: *Kunsthistorische Ausstellung*, Düsseldorf, 1902; *Weltkunst aus Privatbesitz*, Kunsthalle, Cologne, 1968; *Die Zeit der Staufer: Geschichte-Kunst-Kultur*, Württembergisches Landesmuseum, Stuttgart, 1977.

ADORATION OF THE MAGI

The visit of three wise men from the East
to the infant Jesus, as described in the
Gospel of Saint Matthew. The Adoration
of the Magi is commemorated each year
on the feast of Epiphany (January 6).

ADVENT

The season of preparation for Christmas
(the annual commemoration of Christ's
birth on December 25).

ANNUNCIATION

The archangel Gabriel's "announce-
ment" to the Virgin Mary that she
will be the mother of God, as described
in the Gospel of Saint Luke, and the
annual feast commemorating that event
(March 25).

APOCALYPSE

The last book of the Christian Bible in
the western European tradition, also
known as the Book of Revelation. The
Apocalypse contains Saint John the
Divine's description of the events lead-
ing to the end of time, when Christ
will judge all humanity.

ASCENSION

Christ's ascent into heaven forty days
after his Resurrection, as described in
the Acts of the Apostles, and its annual
commemoration.

ASSUMPTION

The "taking up" of the Virgin Mary's
soul to heaven at her death, and the
annual commemoration of that event
(August 15).

CHANT

A liturgical song of the medieval Chris-
tian church, and the body of medieval
liturgical music. The music of medieval
chant consists of a melody sung in uni-
son and unaccompanied by instruments.

CHRISTMAS

The annual commemoration of the birth
of Christ (December 25), one of the most
important feasts of the Christian year.

EASTER

The annual commemoration of Christ's
Resurrection from the dead. The
date of Easter varies from year to year.

EPIPHANY

In the western Church, the annual
commemoration of the Adoration of
the Magi, the Baptism of Christ,
and the Miracle at Cana (January 6).

EUCHARIST

The principal sacrament of the Chris-
tian church, which forms the focus
of the Mass. In the Eucharist, the priest
partakes of the body and blood of

Christ through consecrated bread and wine. The Eucharist takes its name from the Greek word for "thanksgiving," and medieval Christian writers consistently associated the Eucharist with the Jewish tradition of sacrificial offerings.

FEAST

An annual religious celebration that commemorates an event or a saint.

GOSPEL

The "good news" set forth in the accounts of Christ's life attributed to Saints Matthew, Mark, Luke, and John, or one of those accounts.

GOSPEL BOOK

A book containing the accounts of the life of Christ attributed to Matthew, Mark, Luke, and John.

GRADUAL

A book containing the chants of the Mass. Beginning in the tenth century, graduals usually contained not only the text of the chants but also musical notation.

ILLUMINATION

The painted embellishment of a manuscript. The term "illumination" is derived from the Latin verb *illuminare* (to light up).

INCARNATION

The embodiment of God in the human form of Jesus.

LAST JUDGMENT

The final judgment by God of all humanity at the end of time.

LAST SUPPER

The last meal of Christ and his apostles. At the Last Supper, Christ shared bread and wine with the apostles, an act commemorated in the Christian sacrament of the Eucharist.

LECTIONARY

A book of readings. The readings for the Mass are collected in Gospel-lectionaries and epistle-lectionaries, the latter containing readings both from the Epistles of Saint Paul and from Old Testament wisdom literature.

LENT

The season of fasting and penitence in preparation for Easter (the annual commemoration of Christ's Resurrection).

LITURGY

Public or communal religious ritual.

MANUSCRIPT

A book written by hand.

MASS

The principal liturgical rite of the Catholic Church. The focus of the Mass is the Eucharist, the sacrament at which bread and wine are consecrated and consumed.

MINIATURE

A painting in a manuscript.

MISSAL

A book containing the texts—or most of them—necessary for the celebration of the Mass. In missals, the portions of the Mass that are sung may be presented with or without notation.

PENITENCE
The state of regret for faults or sins and resolve to change.

PENTECOST
The Greek name of the Jewish feast of Shavuot, and the annual Christian commemoration of the descent of the Holy Spirit upon the apostles as they were gathered on that day, the seventh Sunday after Christ's death, as described in the Acts of the Apostles.

PSALTER
A book containing the biblical Book of Psalms together with other biblical poetry or devotional texts.

REDEMPTION
Salvation; the deliverance from the penalty for sin through Jesus' sacrifice on the cross.

RELIC
An object of religious veneration, especially a piece of the body of a saint or an object associated with Christ.

RESURRECTION
The "rising again" of Christ from the dead three days after his Crucifixion, and the rising of all souls at the Last Judgment.

SACRAMENT
One of the formal religious rites of the Church through which the faithful experience God's love and protection.

SACRAMENTARY
A book containing the texts of the prayers recited by the celebrating priest at Mass.

SALVATION
Redemption; the deliverance of humanity from the penalty for sin through Jesus' sacrificial death.

SECOND COMING
The return of Christ as judge at the end of time.

SEQUENCE
A fairly long chant sung at Mass before the reading of a passage from the Gospels.

TYPE
A figure or event that foreshadows one yet to come.

TYPOLOGY
The method of scriptural interpretation whereby persons or events in the Hebrew Bible—types—are seen to prefigure persons or events in the New Testament or the history of the Church.

VERSICLE
A short verse sung during prayer services.

The Artistic Heritage of the Monastery of Saint Michael

M. Brandt and A. Eggebrecht, eds., *Bernward von Hildesheim und das Zeitalter der Ottonen*, 2 vols. (Hildesheim, 1993).

U. Knapp, ed., *Buch und Bild im Mittelalter* (Hildesheim, 1999).

M. Stähli, *Die Handschriften im Domschatz zu Hildesheim* (Wiesbaden, 1984).

Early Medieval Mass Books and Their Illumination

E. Palazzo, *Le moyen âge: Des origines au XIIIe siècle*, Histoire des livres liturgiques (Paris, 1993).

R. Suntrup, "Te igitur-Initialen und Kanonbilder in mittelalterlichen Sakramentarhandschiften," in *Text und Bild: Aspekte des Zusammenwirkens zweier Künste in Mittelalter und früher Neuzeit*, C. Meier and U. Ruberg, eds. (Wiesbaden, 1980), pp. 278–382.

Jewish Scripture in Christian Art

P. Bloch, "Typologische Kunst," in *Lex et Sacramentum im Mittelalter*, P. Wilpert, ed., Miscellanea Mediaevalia, 6 (Berlin, 1969), pp. 127–42.

L. Goppelt, *Typos: The Typological Interpretation of the Old Testament in the New*, D.H. Madvig, trans. (Grand Rapids, 1982).

R. R. Ruether, *Faith and Fratricide: The Theological Roots of Anti-Semitism* (Wipf and Stock, 1997).

The Stammheim Missal and Its Illumination

S. Beissel, "Ein Missale aus Hildesheim und die Anfänge der Armenbibel," *Zeitschrift für christliche Kunst* 15 (1902), cols. 265–74 and 307–18.

J. Günther, *Handschriften und Miniaturen aus dem deutschen Sprachgebiet*, Katalog 5 (Hamburg, 1997), no. 3 (pp. 22–35).

A. K. Menke, "The Ratmann Sacramentary and the Stammheim Missal: Two Romanesque Manuscripts from Saint Michael's at Hildesheim (Germany)," unpubl. Ph.D. dissertation, Yale University, 1987.

Glossary

Richard P. McBrien, ed., *The HarperCollins Encyclopedia of Catholicism* (San Francisco, 1995).

ACKNOWLEDGMENTS

It has been a great pleasure to write about the Stammheim Missal, a truly magnificent monument of medieval art that constantly repays study. It has also been a challenge to present such a physically and theologically complex object to a novice audience, and many colleagues and friends have helped me in the undertaking. Thomas Kren, Curator of Manuscripts at the J. Paul Getty Museum, generously embraced the idea of my writing such a book and offered suggestions for improving the text along the way. An amiably vocal group of colleagues from the Getty and UCLA gave various bits of advice within the context of a Museum seminar. Andrea Bolland, Eric Palazzo, and Richard W. Pfaff read and commented on the typescript. Although I could not adopt all their suggestions, each contributed to the text's final form. I am especially grateful to Elizabeth Sears for her close and discerning reading of the typescript; I only hope I may one day repay the debt. Mollie Holtman kept me on my toes through the editing process, Jeffrey Cohen designed a book worthy of the book that is its subject, and Suzanne Petralli Meilleur kept us all on track.